Draw Horses
with
Sam Savitt

Also by Sam Savitt

Draw Horses

with
Sam Savitt

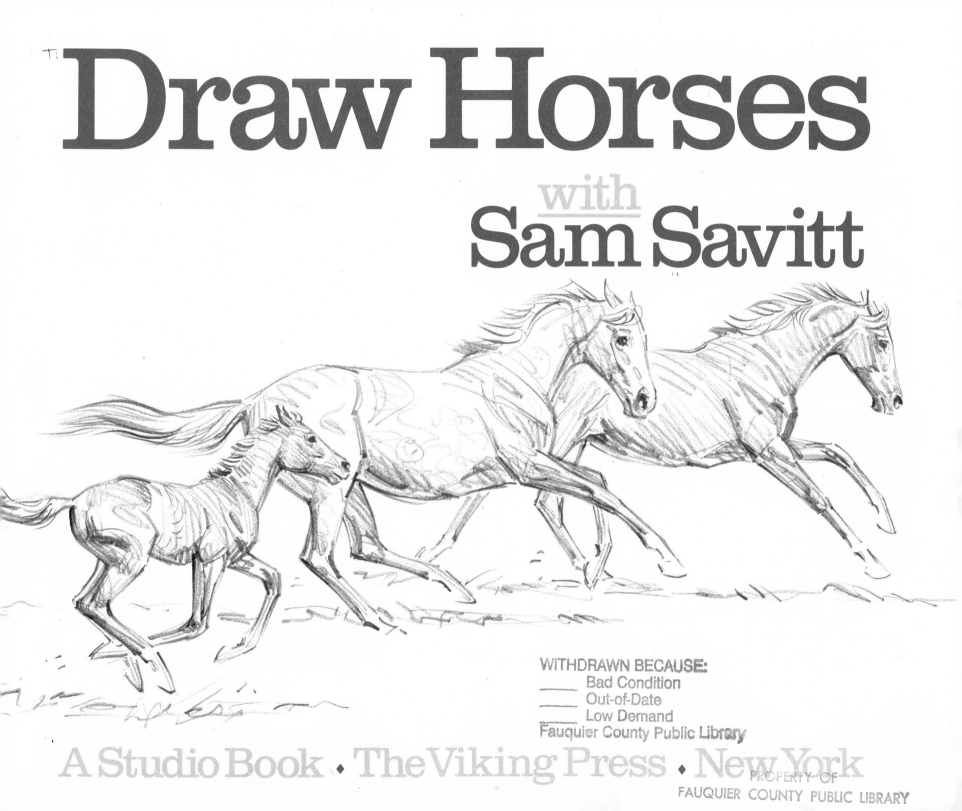

A Studio Book • The Viking Press • New York

To my wife, Bette

Copyright © 1981 by Sam Savitt
All rights reserved
First published in 1981 by The Viking Press (A Studio Book)
625 Madison Avenue, New York, N.Y. 10022

Published simultaneously in Canada by
Penguin Books Canada Limited

Library of Congress Cataloging in Publication Data
Savitt, Sam.
 Draw horses with Sam Savitt.
 (A Studio book)
 SUMMARY: A step-by-step guide to drawing various
horses in motion and at rest.
 1. Horses in art. 2. Drawing—Technique.
II. Drawing—Technique. 2. Animal painting and
illustration. 3. [Horses in art] I. Title.
NC780.S23 743′.69725 80-21812
ISBN 0-670-28259-6

Printed in the United States of America by
the Murray Printing Company, Westford, Massachusetts

Set in Century Schoolbook

CONTENTS

In order to create a good painting of a horse from life or from a photograph, an artist must paint what he or she knows in addition to what he sees, and he must know a great deal more than he sees.

Many equestrian painters today do not really *draw* horses. They copy with paint all the lights and darks they see in a photograph, but what they do not seem to know is that photographs often distort form. Unless an artist understands the construction of the horse and how it functions, his pictures are no more than a meaningless collection of light and dark areas.

A good drawing can be a valued entity in itself, but, more important, it is a necessary foundation for a good painting. Many of the old masters made countless drawings of their subjects before they began to paint them.

All the drawings in this book were done with pencils—both hard and soft. At times I wedged the point to get a halftone effect; at other times I used the point right out of the pencil sharpener to get a linear effect. The tools I use to create a drawing are relatively unimportant, however, for there are many ways to accomplish the same thing. Once you have mastered the art of drawing, you will be able to pull a horse right out of your head and make him come alive in whatever medium you are using.

I have been fascinated by horses all my life. As a child I actually wanted to *be* a horse. I copied their actions in every way I could. I was a harness horse for a while, pulling the neighborhood kids about in a coaster wagon and holding a rope bit in my mouth for the sake of realism. I allowed myself to be tied up and would stand in the corner of a room for long periods, shifting my weight from one leg to the other as I had seen horses do. Once at the dinner table I even stuck my face down into a bowl of soup and slurped it up the same way a horse would. I was forever imitating horses. To imitate, one must observe, and observing and remembering were my first steps in learning to draw horses.

Of course I don't expect you to go through the same shenanigans that I did, but I want you to understand that there is no magic involved in drawing. In fact, drawing can be as simple as writing. You must learn to form letters before you can make a word. In order to draw a horse, you must learn to form the parts before you can make the whole horse.

Drawing is a skill that can be learned by anyone with average eyesight and average eye-hand coordination. If you can thread a needle or catch a ball, you can learn to draw. If your handwriting is readable or if you can print legibly, you have enough dexterity to draw well. Drawing is not very difficult. *Seeing* is the problem. You may feel that you see things just fine and that drawing them is the hard part, but actually the opposite is true.

Knowing how the horse might react in a given situation will determine what you will do with him in a drawing. Remember that the horse is a creature of flight, not fight. He will shy at the drop of a hat or practically leap out of his skin at the mere sight of a rock. Yet, strangely enough, he can be taught to gallop headlong into gunfire or to jump over tremendously imposing obstacles. He is basically a herd animal, preferring the company of other horses, but he and man have struck up a special relationship that has carried them together through centuries of war, work, sport, and art.

Every bit of knowledge you pick up about horses will come to your aid when you draw them. If possible, you should visit horses, talk to them, run your hands over their sleek backs and hard legs. Observe them constantly wherever and whenever you can—in real life, in photographs, in movies, and on television. Study all the drawings of horses you can find to see how other equestrian artists have handled the subject. On the following pages you will see drawings of horses doing just about everything that horses do. You will undergo a continuous test of your observation. Make the most of it, for watching horses is the best way to learn about them.

One exercise to improve your power of observation is to study a drawing or photograph of a horse for a minute or two, then remove the picture from your vision and try to draw what you remember.

If you have a live horse to work from, this exercise is even more challenging, for even the quietest horse is usually in motion—grazing or fidgeting in his stall. But you don't necessarily have to draw the whole horse; a back leg, front leg, or any other part will do while you are learning to observe.

I have often noticed that when I am riding in an automobile as a passenger over an unknown route I rarely remember the road as well as if I were driving that automobile myself over that same road. The reason for this is that when I am driving I am observing and concentrating on the way I am going. If you consider yourself the "driver" when you are drawing a horse, you will remember all the twists and turns of his conformation.

Later in this book I will show you methods of working that I have used to get effective results. But first you will learn the basics of drawing a horse. Then you can begin to emphasize, and perhaps exaggerate, the things about him that you particularly like. In the long run, your own point of view will become your style. At all times keep in mind that you must never sacrifice the artistic quality of your drawing for the horse as you see him. By that I mean you should draw horses like an artist—not like a technician. If a highlight or a shadow disturbs the form, eliminate it in your drawing in order to clarify what you are trying to show.

Now let me show you how to look at a horse, and remember that sight is a faculty, but seeing is an art.

Learning the names of the different parts of the horse will
enable you to locate the areas I refer to as we go along.

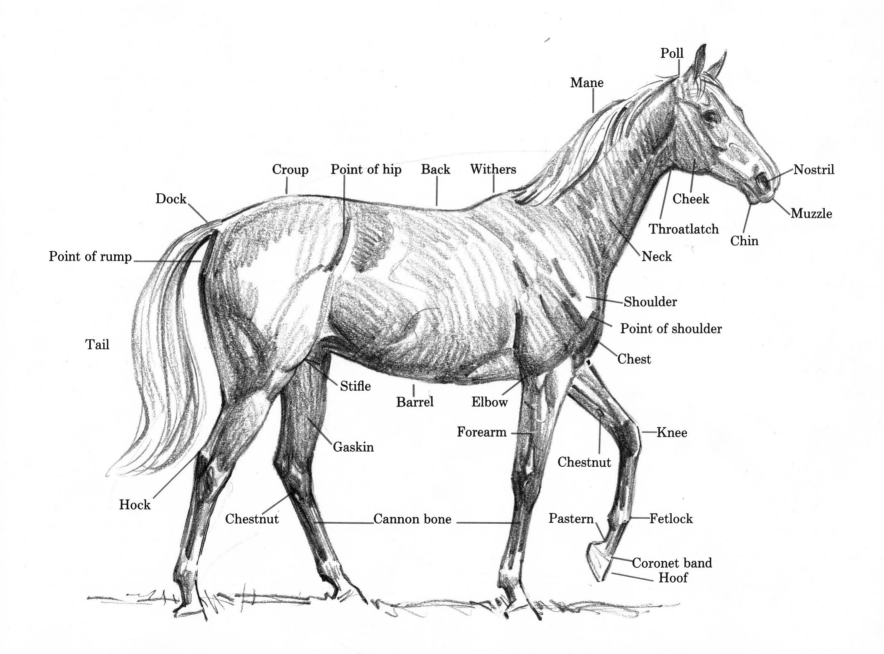

Poll

Mane

Croup Point of hip Back Withers

Dock

Nostril

Cheek

Point of rump

Throatlatch

Muzzle

Chin

Neck

Tail

Shoulder

Point of shoulder

Chest

Stifle

Barrel Elbow

Gaskin

Forearm

Knee

Chestnut

Hock

Chestnut Cannon bone Pastern Fetlock

Coronet band
Hoof

SKELETAL STRUCTURE

The horse's head is normally carried at a right angle to the line of the neck.
Fig. 1 shows the head put on incorrectly.
Fig. 2 shows the head put on correctly.

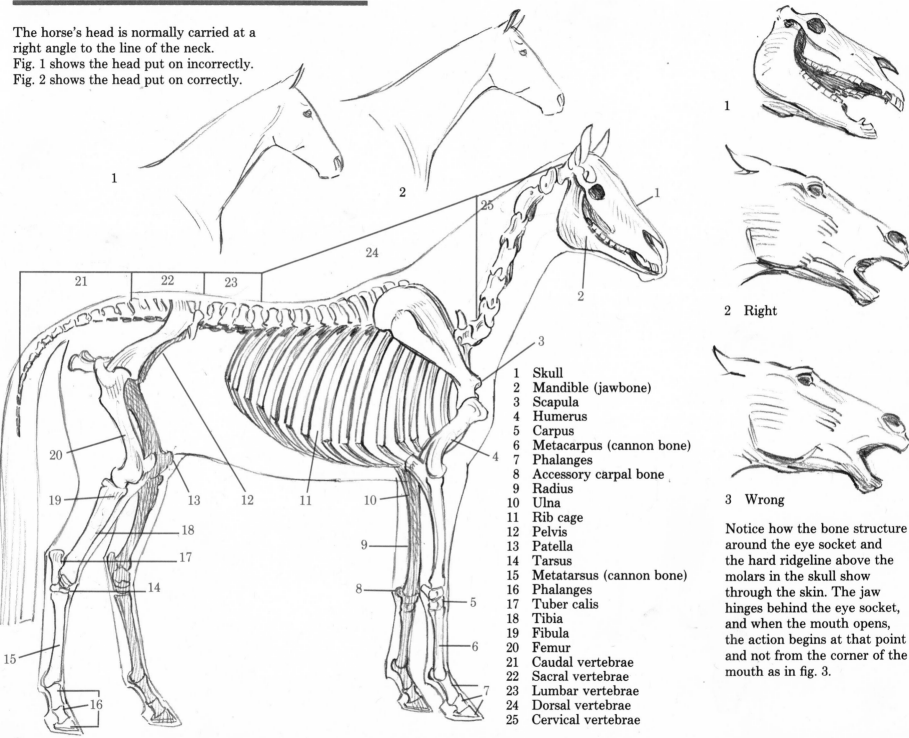

1 Skull
2 Mandible (jawbone)
3 Scapula
4 Humerus
5 Carpus
6 Metacarpus (cannon bone)
7 Phalanges
8 Accessory carpal bone
9 Radius
10 Ulna
11 Rib cage
12 Pelvis
13 Patella
14 Tarsus
15 Metatarsus (cannon bone)
16 Phalanges
17 Tuber calis
18 Tibia
19 Fibula
20 Femur
21 Caudal vertebrae
22 Sacral vertebrae
23 Lumbar vertebrae
24 Dorsal vertebrae
25 Cervical vertebrae

1

2 Right

3 Wrong

Notice how the bone structure around the eye socket and the hard ridgeline above the molars in the skull show through the skin. The jaw hinges behind the eye socket, and when the mouth opens, the action begins at that point and not from the corner of the mouth as in fig. 3.

8

MUSCULAR SYSTEM

1 Brachiocephalicus
2 Deltoideus
3 Pectoralis
4 Triceps brachii
5 Extensor carpi radialis
6 Extensor digitorum
7 Tibialis anterior
8 Extensor digitorum
9 Flexor digitorum
10 Biceps femoris
11 Semitendinosus
12 Glutaeus
13 Quadriceps femoris
14 Obliquus obdominis extensor
15 Latissimus dorsi
16 Trapezius
17 Sterno cephalicus

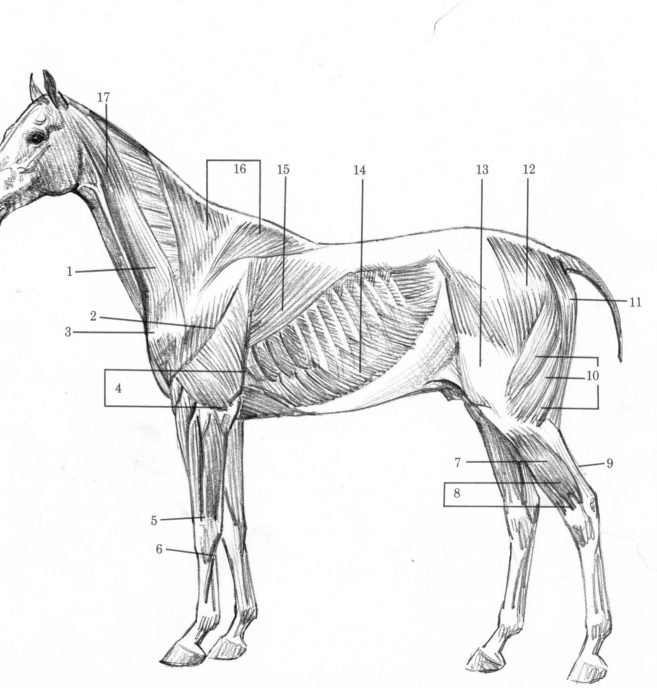

9

Although the head of any particular horse will be different from the heads of other horses, it will be useful for you to learn the general proportions of the ideal horse's head in order to draw the individual with overall accuracy. I draw rectangles and boxes as guidelines.

Front view

1. Draw a rectangle two and a half times higher than it is wide and divide it in half as shown.
2. Divide the upper part in half and draw two interlocking diamond shapes as indicated.
3. Put eyes and nostrils in place.
4. Draw the rest of the head using the diamond shapes as a guide.

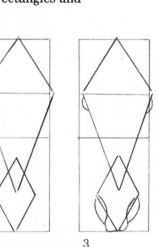

Side view

1. Make the same rectangle as above but on an angle and divide it in half.
2. Divide the upper part in half and draw in the muzzle and cheek lines.
3. Place the eye on the dividing line in the upper part and complete the rest of the head as shown. Note that the ridge of the cheekbone below

the eye runs in the same direction as the mouth. Note also that the halfway line of the rectangle is just above the indentation marking the jaw muscle.

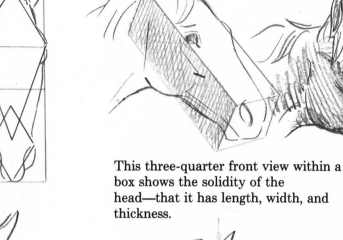

This three-quarter front view within a box shows the solidity of the head—that it has length, width, and thickness.

The same holds true for the three-quarter back view.

The Ears

The ears are shaped somewhat like funnels. They do not change their shape much, but they move so frequently that you might think they do. Here are a few tips for keeping track of them.

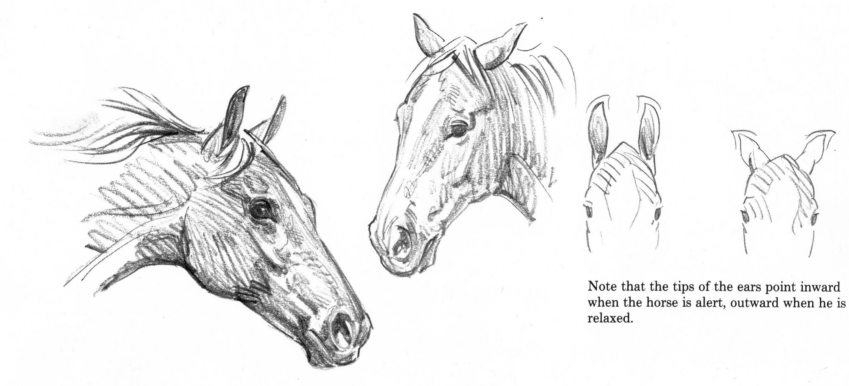

Note that the tips of the ears point inward when the horse is alert, outward when he is relaxed.

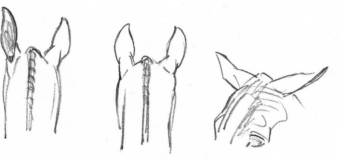

The ears can move together or separately.

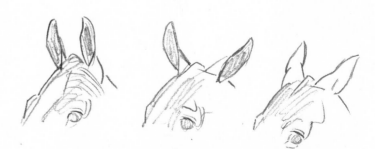

The ears will tell you if a horse is sharply alert or relaxed.

The Eyes

The eyes help to give the head character and expression. They are situated on the sides of the head as shown in fig. 1. Notice how the position of the eye seems to change as the head turns toward a three-quarter view.

It is incorrect to place eyes in the front part of the head.

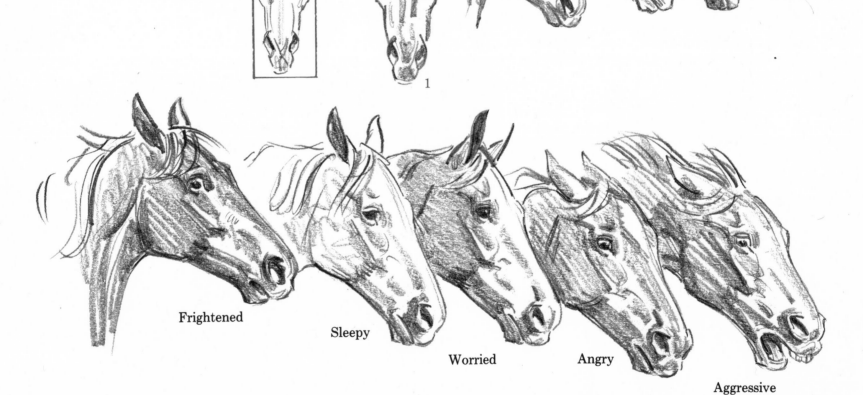

1

Frightened

Sleepy

Worried

Angry

Aggressive

Different expressions are obtained by altering the position of the eyelid and the highlight in the eye. Note that the ears flatten against the skull when the horse is angry or about to attack.

The Nostrils and Mouth

The nostrils and mouth are as expressive as the eyes. Notice how they change shape under different conditions.

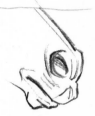 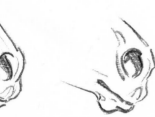 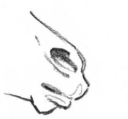 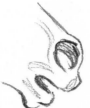

The nostril when relaxed resembles a number 6.

As it expands, it looks more like an O.

The nostril flattens when the horse reaches for a tidbit

and expands when he yawns.

Front view of relaxed nostrils.

Front view of expanded nostrils.

Look at the varied expressions you can get when you coordinate the ears, eyes, nostrils, and muzzle.

Attention

All-out exertion

Curiosity

Preoccupation

Annoyance

In the flehmen posture, the horse's upper lip curls back and his neck is extended. This expression seems to indicate that the horse smells something interesting or unpleasant.

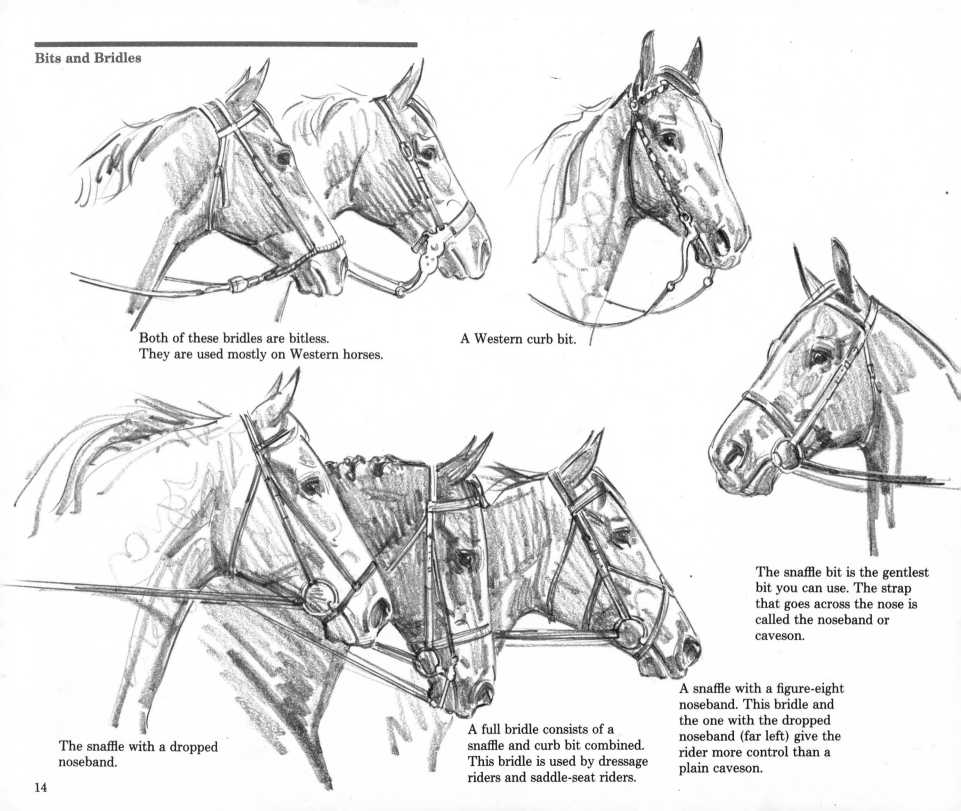

Both of these bridles are bitless. They are used mostly on Western horses.

A Western curb bit.

The snaffle bit is the gentlest bit you can use. The strap that goes across the nose is called the noseband or caveson.

The snaffle with a dropped noseband.

A full bridle consists of a snaffle and curb bit combined. This bridle is used by dressage riders and saddle-seat riders.

A snaffle with a figure-eight noseband. This bridle and the one with the dropped noseband (far left) give the rider more control than a plain caveson.

The legs and all their parts must be drawn clearly and sharply. This is important because any line not clearly drawn may be misread as a fault in their structure.

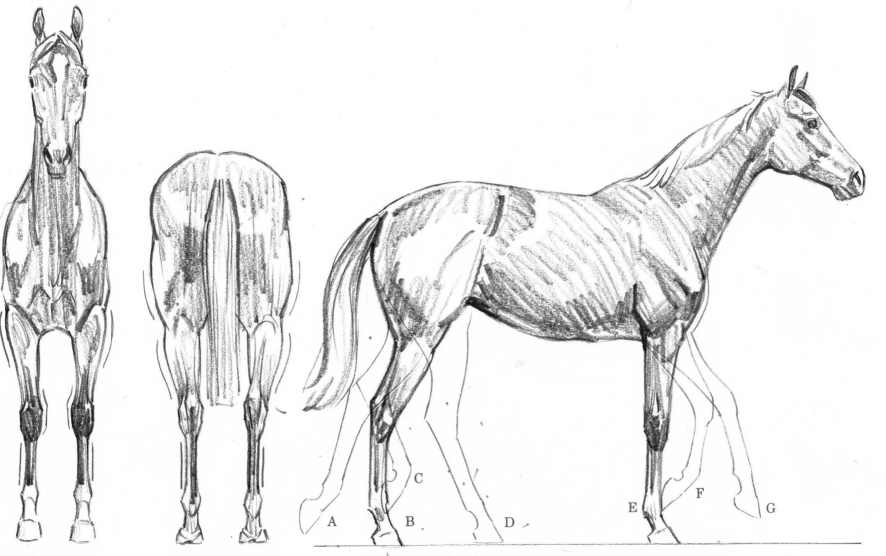

Note the bulging forearms and knock-kneed appearance of the front legs.

Note the outward bulge of the hindquarters and gaskins and the perpendicular straightness of the cannon bones.

When a leg moves, the structure to which it is attached also moves. See how the hoof in B and E snaps downward as the leg moves forward and backward. Also notice how the angle of the pastern (A through G) changes as the horse moves.

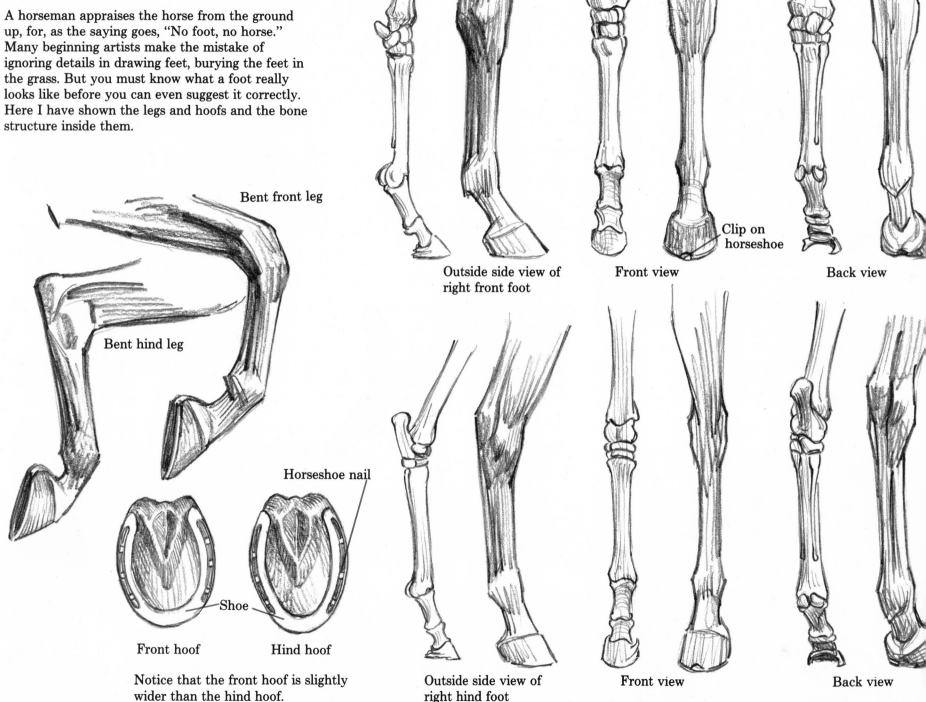

The Feet

A horseman appraises the horse from the ground up, for, as the saying goes, "No foot, no horse." Many beginning artists make the mistake of ignoring details in drawing feet, burying the feet in the grass. But you must know what a foot really looks like before you can even suggest it correctly. Here I have shown the legs and hoofs and the bone structure inside them.

Bent front leg

Bent hind leg

Horseshoe nail

Shoe

Front hoof

Hind hoof

Notice that the front hoof is slightly wider than the hind hoof.

Outside side view of right front foot

Front view

Clip on horseshoe

Back view

Outside side view of right hind foot

Front view

Back view

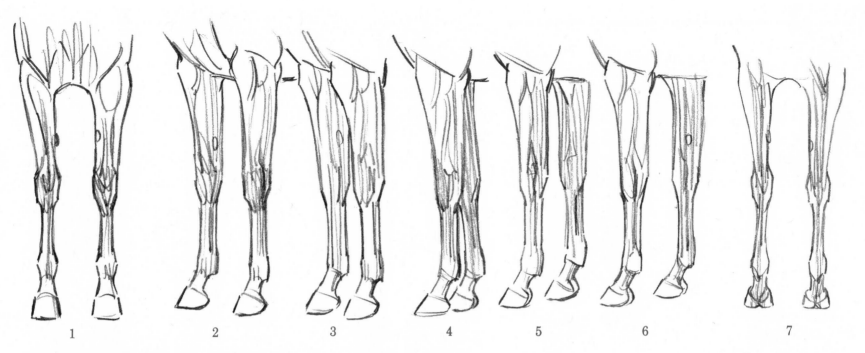

Moving around the front legs from direct front (fig. 1) to direct rear (fig. 7).

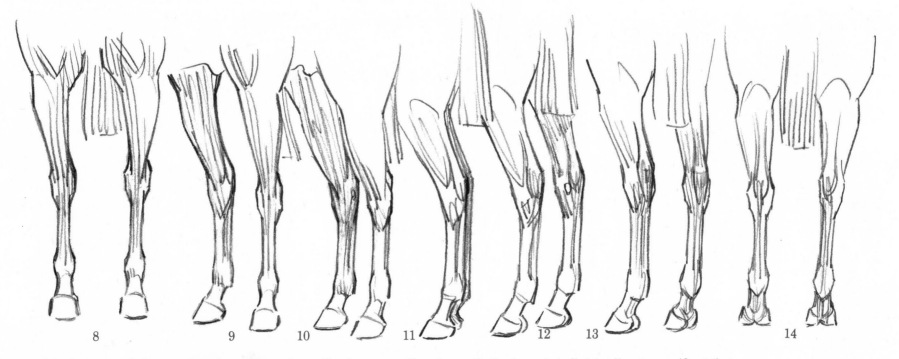

Moving around the rear legs from direct front (fig. 8, as seen from beneath the horse's belly) to direct rear (fig. 14).

17

Horses vary in conformation, but I find the square device below a good general guide to overall proportions when I begin drawing any horse.

The body and legs of the ideal horse fit in a square.

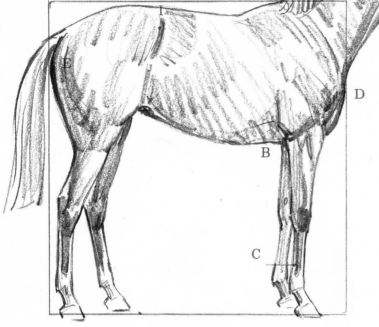

The horse with a short wheelbase falls short of the horizontal measurement of the square.

The distance from the top of the withers (A) to the ground is equal to the distance from the point of the shoulder (D) to the point of the rump (E).

The distance from (F) to (G) equals the distance from (H) to (D).

The distance from the poll (F) to the muzzle (G) equals the distance from the elbow (B) to the bottom of the cannon bone (C).

The distance from (A) to (B) equals the distance from (A) to (F).

The distance from (A) to (B) equals the distance from (A) to the point of the hip (I).

The distance from (F) to (G) equals the distance from (I) to the point of the rump (E).

There is often a tendency to draw the head too small. Remember that the length of the head is approximately the same as the distance between B and C. Note that the top line of the neck is longer than the bottom line of the neck. Also see how the large muscle of the neck forms a direct line to the ear.

Many well-built horses extend beyond the horizontal measurement of the square. Some of the best jumpers are horses with a long wheelbase like this.

The body is made up of a series of cylinders and sections that fit together.

When you start a drawing, it does not matter if you begin with the head or with the hindquarters. All that matters is that each line you put down has meaning. Every line should have a beginning and an end, for these lines will say whether the part you are drawing is round or oval. Touch a real horse whenever possible. Run your hands over him and feel the softness of some areas and the hardness of others, and try to convey the differences in your drawing.

The colored lines on this page indicate areas that will not be visible in the finished work, but you must be conscious of them when you are drawing. Try to visualize the invisible parts beneath the surface as you work. This will help you draw a horse that is solid and three-dimensional.

Looking at the whole horse from different angles is a good exercise in seeing. Be especially aware of how individual parts relate to each other.

1

2

3

As you approach the horse from the front, be aware of how the neck joins the shoulder and how the shoulder fits into the barrel, which in turn connects with the hindquarters.

As you go by his right side, you will begin to see more barrel and more of the hindquarters. The shape of the legs will not change much until you are alongside them.

From this angle, the legs look quite different. Now you can observe the true relationships between the parts of the horse, undistorted by foreshortening. This is why conformation portraits always show the horse in this position.

4

As you go toward the rear of the horse, you will begin to see him in an entirely different perspective. Notice how the parts fit together from this angle, especially the legs.

5

The horse doesn't bother to turn his head since his eyes are on the side of his head and he can still see you well enough from this angle.

6

Now the horse turns to make sure you are still watching him. Did you watch closely? Did you notice that I put a halter on the head of the horse in fig. 3? I also make my horses switch their tails occasionally to give my drawings more interest. I ruffled this horse's mane for the same reason.

Now that we have had a good look at the horse standing still, let's see what happens when he goes into action. The most important thing to remember is that all parts of the horse are connected by bone and sinew and that the movement of one part always influences the parts that adjoin it. Although the basic construction of each part we studied in chapter 1 does not change, the relationships between the parts will vary each time the horse moves and each time we view him from a different angle.

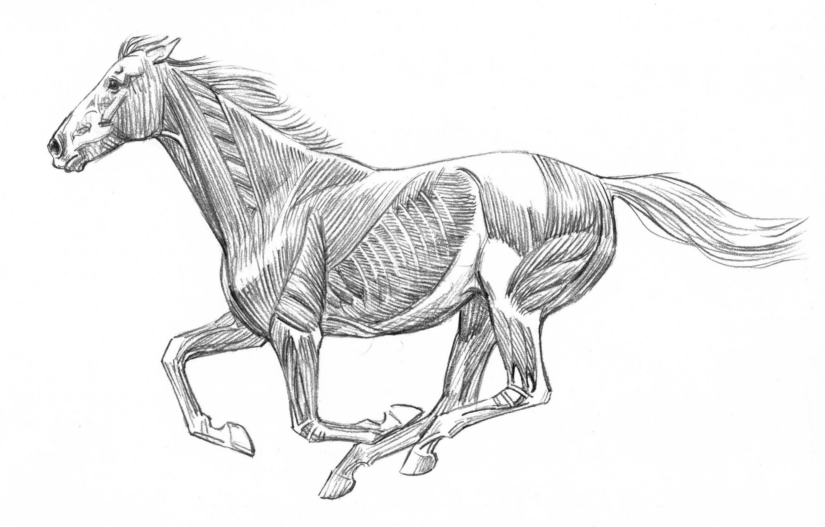

MUSCULAR SYSTEM IN A GALLOPING HORSE

See page 9 for the names of important muscular groups.

When you begin to make an action drawing, try to feel the horse's movement within yourself as you draw. The various gaits have a rhythm of their own. The jump is smooth and graceful, while the buck is erratic and jerky. Each person will experience the action in his own way. But first you should understand the underlying structure and how it is affected by movement.

SKELETAL STRUCTURE IN A TROTTING HORSE

Refer to page 8 for the names of bones and compare the two drawings to see how action has affected their position.

The horse's walk is a diagonal action; that is, when the left front foot begins to leave the ground, the right hind foot will follow (figs. 1–6), and the same is true of the right forefoot and the left hind (figs. 9–12). Notice that as the leg moves, the entire section of shoulder to which it is attached also moves. Figs. 4, 5, and 6 show the left shoulder moving forward with the left foreleg. Figs. 9–12 show the right shoulder swinging forward with the right foreleg. This rule also applies to the hindquarters.

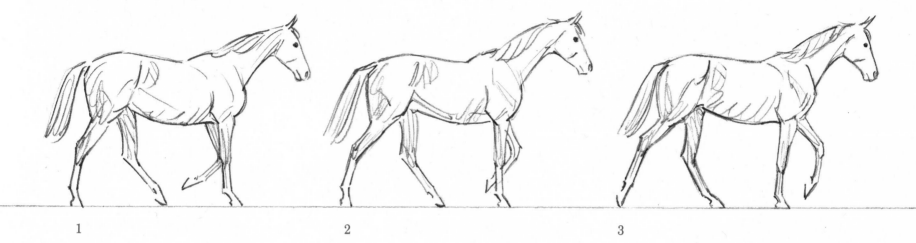

1 2 3

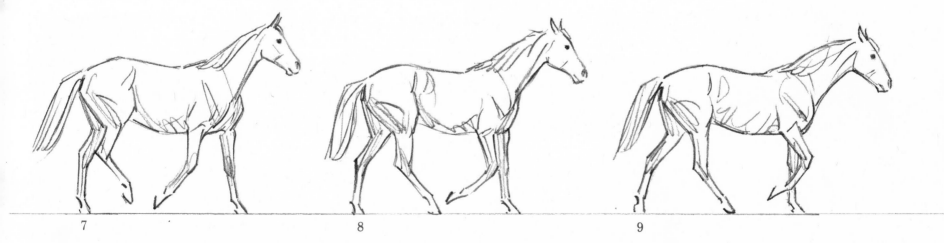

7 8 9

Different horses carry their heads differently when they walk. Some carry them high, others low. The horse in this walking sequence carries his head pretty much in the middle. The length of the stride will also vary from horse to horse. Generally, the taller the horse, the longer the stride, although I have known small horses with long strides and tall horses with relatively short strides. The next time you have the opportunity to watch horses in motion, be sure to make note of these individual variations.

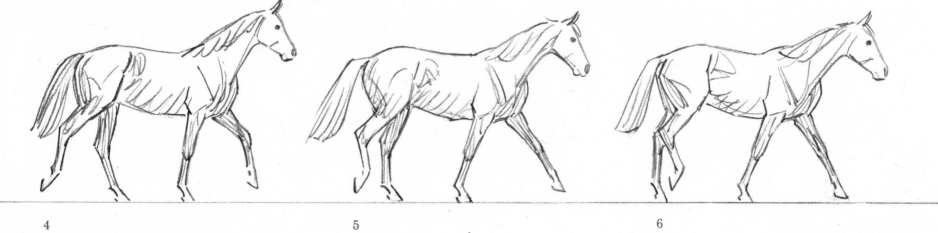

4 5 6

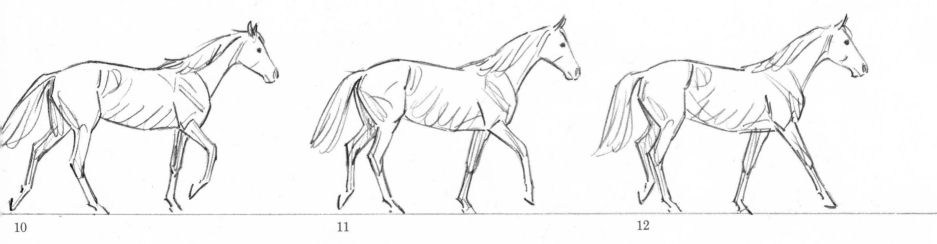

10 11 12

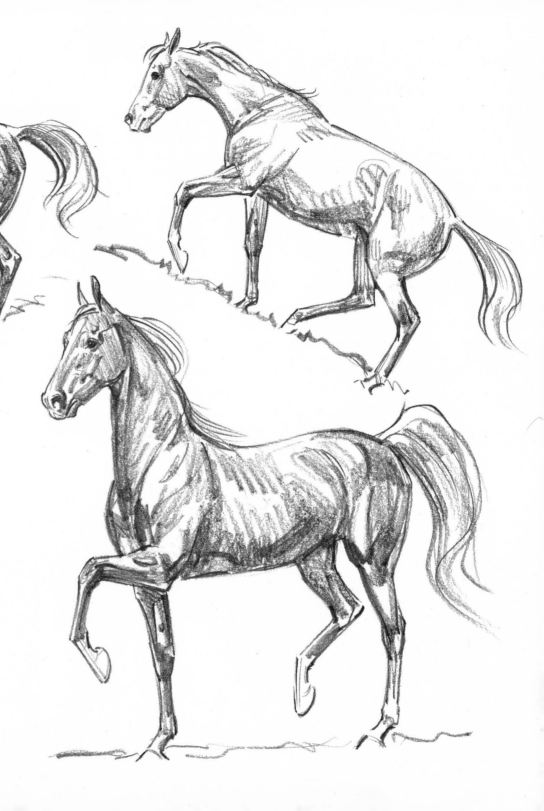

While walking uphill, the horse pushes
forward—leaning a little into the hillside.
Going downhill, however, he braces himself
and moves more carefully with almost
mincing steps, keeping his weight back.

The American Saddle Horse (right) has a
high-stepping walk all his own.

On this page you can study the horse coming and going at a walk.

In fig. 1 the horse walking toward you is in the same part of the stride as the horse in fig. 3 walking away from you. Figs. 2 and 4 also show the same stride from two different angles.

In figs. 1 and 3 the left foreleg is moving forward. In figs. 2 and 4 the left foreleg is about to meet the ground and the right hind is coming forward. Notice that in figs. 2 and 4 the horse's weight is supported by diagonally located legs—right front and left hind.

1

2

3

4

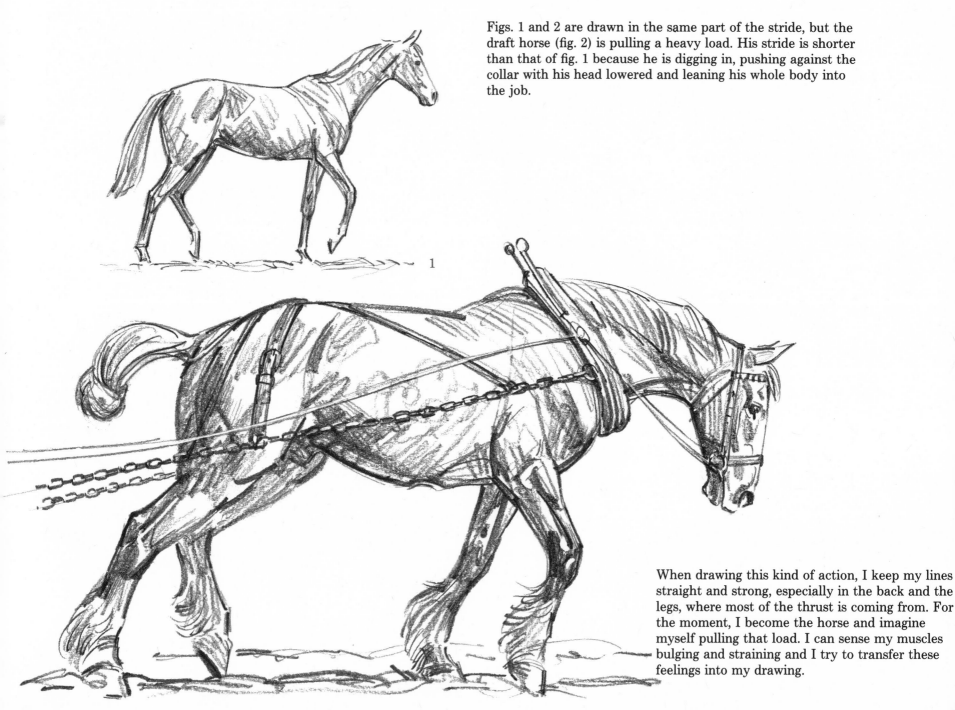

Figs. 1 and 2 are drawn in the same part of the stride, but the draft horse (fig. 2) is pulling a heavy load. His stride is shorter than that of fig. 1 because he is digging in, pushing against the collar with his head lowered and leaning his whole body into the job.

1

When drawing this kind of action, I keep my lines straight and strong, especially in the back and the legs, where most of the thrust is coming from. For the moment, I become the horse and imagine myself pulling that load. I can sense my muscles bulging and straining and I try to transfer these feelings into my drawing.

2

The horse in fig. 4 is bearing down once again as he pulls up the hill. I have lowered his head and distended his nostrils in order to help give an impression of strain and effort. Notice that his stride is a bit more advanced than in fig. 3.

3

In fig. 3 the horse is pulling, but he is already under way and is therefore not pressing as hard as he was when he started out in fig. 2.

4

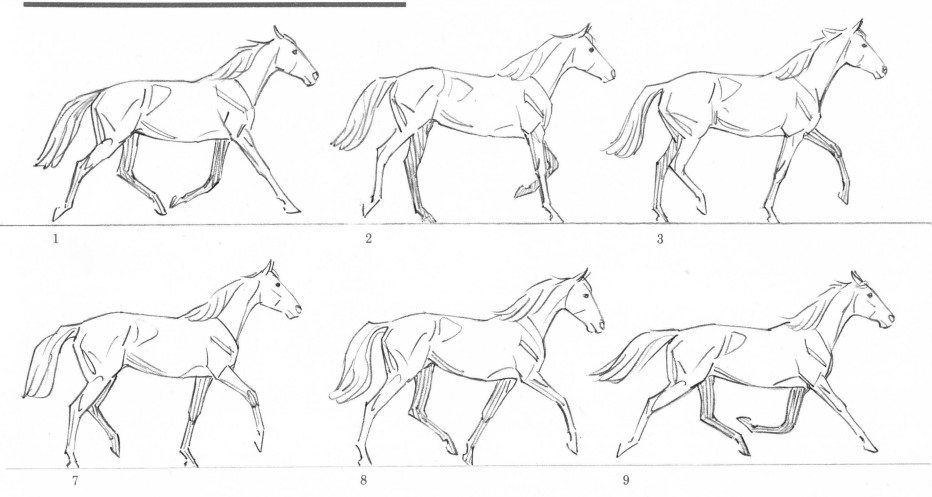

1

2

3

7

8

9

The trot, like the walk, is a diagonal action. The stride is measured from the spot where one foot leaves the ground to the point where it touches again. Notice that when a horse is trotting, there are times when all four feet are off the ground at once (figs. 1, 5, 9).

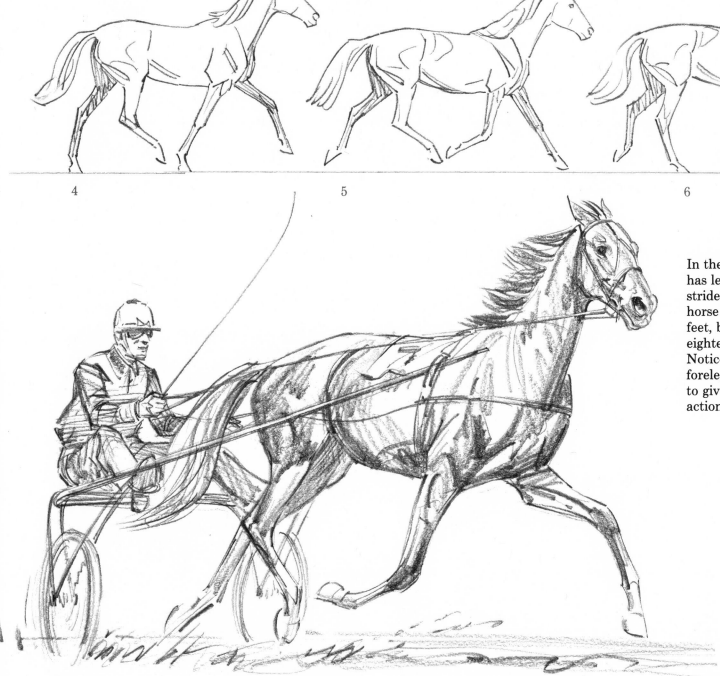

4

5

6

In the drawing at the left, the horse has lengthened his stride. The stride of a medium-sized trotting horse might measure about seven feet, but a racing trotter can cover eighteen to nineteen feet in a stride. Notice the extreme stretch of the forelegs and the devices I have used to give my drawing the feeling of action.

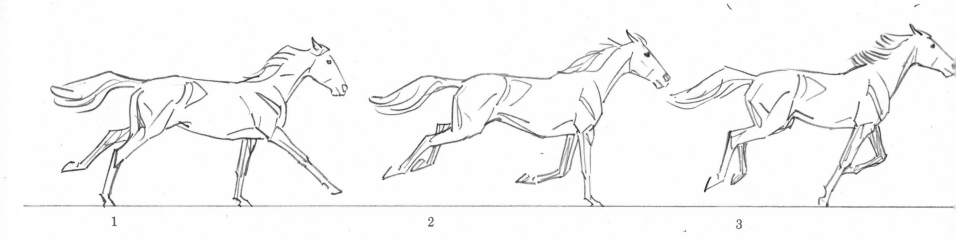

1 2 3

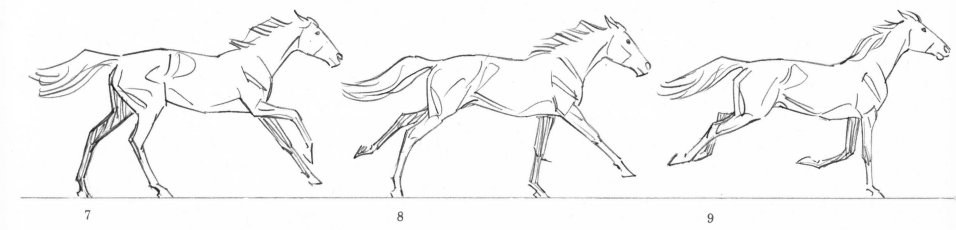

7 8 9

The gallop is the horse's fastest gait. When a horse is running flat out, his stride may cover about twenty feet. But when a big-going racehorse, such as the great Secretariat, moves out, his stride may well measure twenty-seven or twenty-eight feet. Notice the extreme slope of the pastern (figs. 2 and 9) when all the horse's weight is carried on one foreleg. Note also that there is a longer period of suspension in the gallop (figs. 4 and 5) than in the canter (page 34, fig. 8).

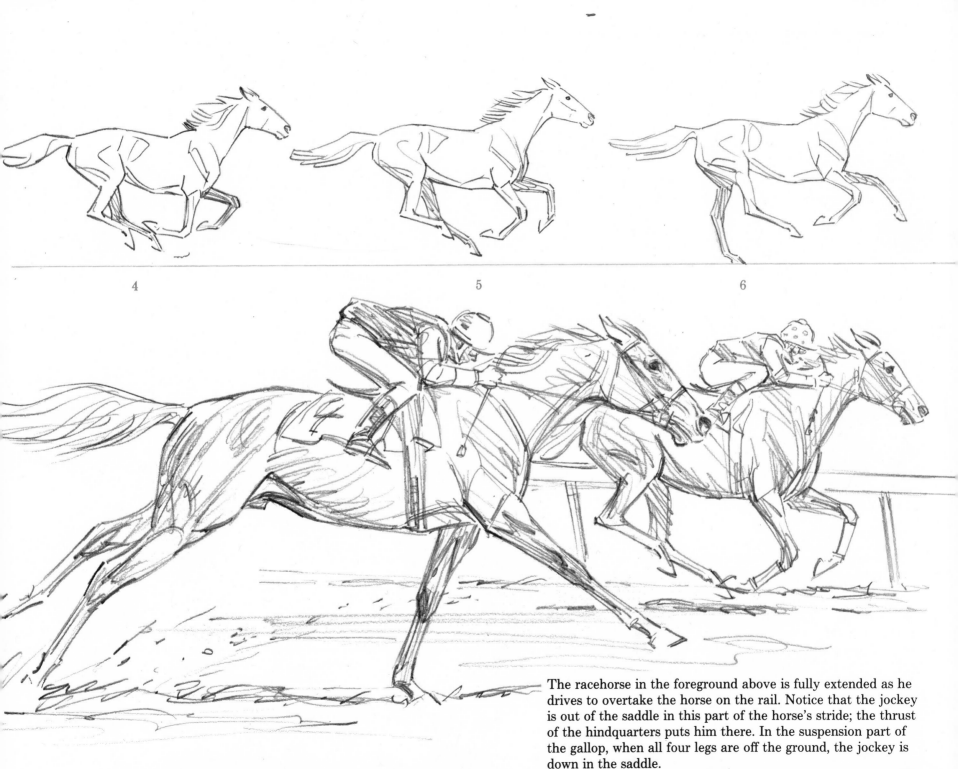

4 5 6

The racehorse in the foreground above is fully extended as he drives to overtake the horse on the rail. Notice that the jockey is out of the saddle in this part of the horse's stride; the thrust of the hindquarters puts him there. In the suspension part of the gallop, when all four legs are off the ground, the jockey is down in the saddle.

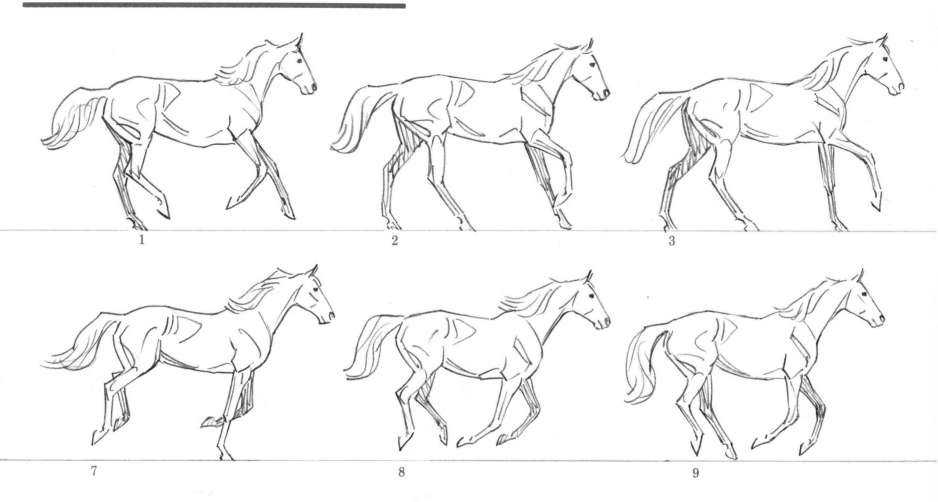

The canter is a collected version of the gallop. Unlike the faster gait, however, most of the movement of the horse is up and down rather than forward. It is a three-beat, easy-rolling gait. Try to feel that as you draw. Keep the ears pointed forward and the entire attitude of the horse both alert and relaxed.

Note that the horses in figs. 11 and 12, cantering toward you and away from you, are in the same part of the stride as the horses in figs. 1 and 10.

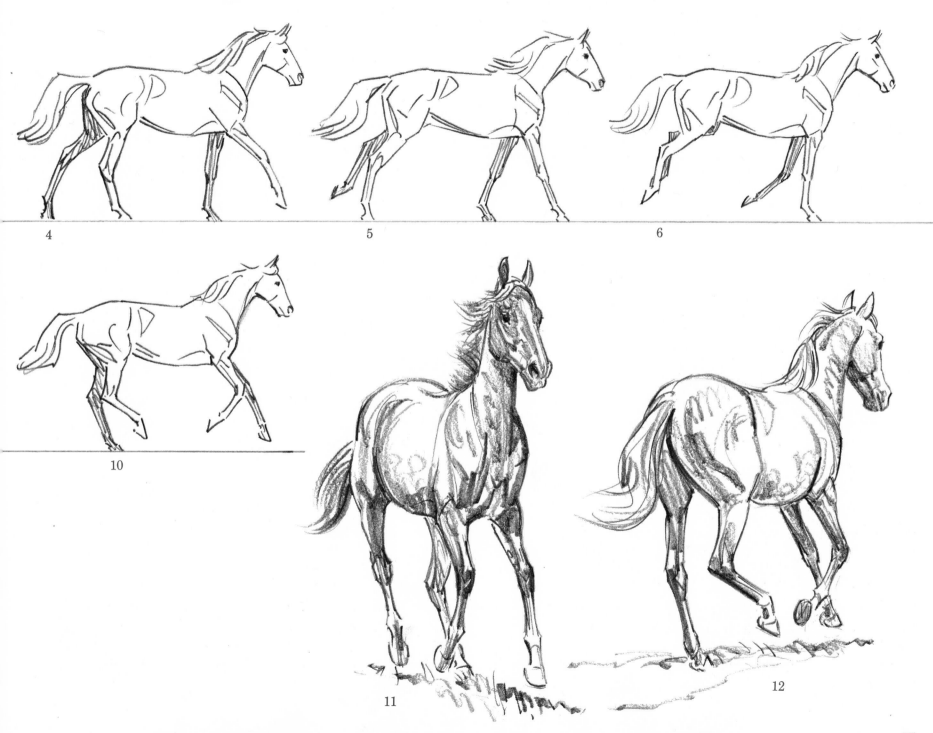

4

5

6

10

11

12

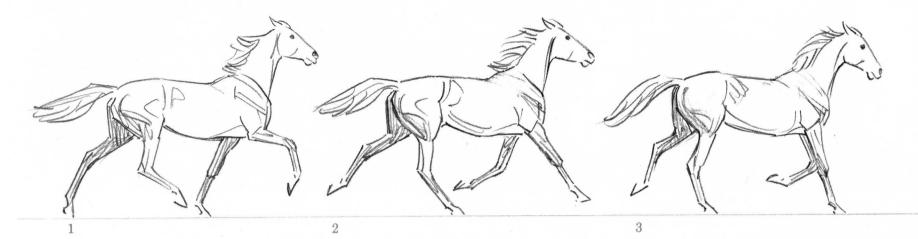

1 2 3

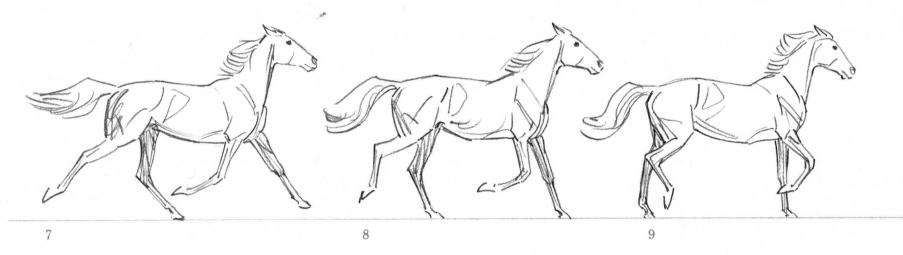

7 8 9

The pace is a two-beat gait in which the lateral legs (those on the same side of the horse) move together. The fast or racing pace is often faster than the trot. This gait has a period of suspension (fig. 6) when four legs are off the ground.

Fig. 10 on the opposite page is pacing, while fig. 11 is trotting. Note that the pacing action is lateral, with the left front and left hind legs moving in the same direction at the same time. In the trotting horse, the leg action is diagonal, with the left hind and right front legs moving simultaneously.

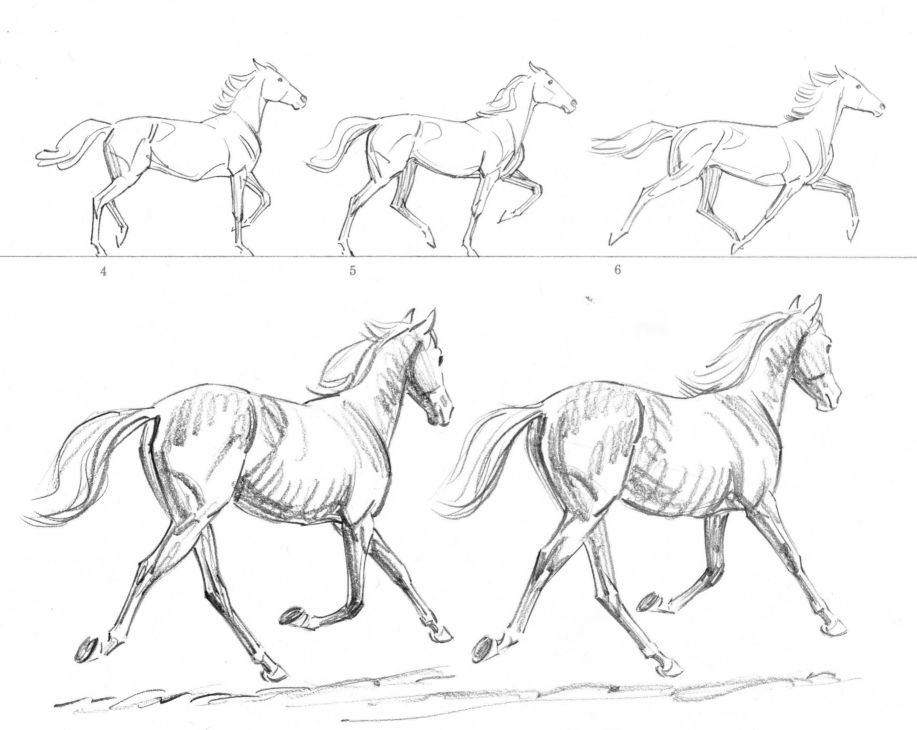

4

5

6

10 Pacer

11 Trotter

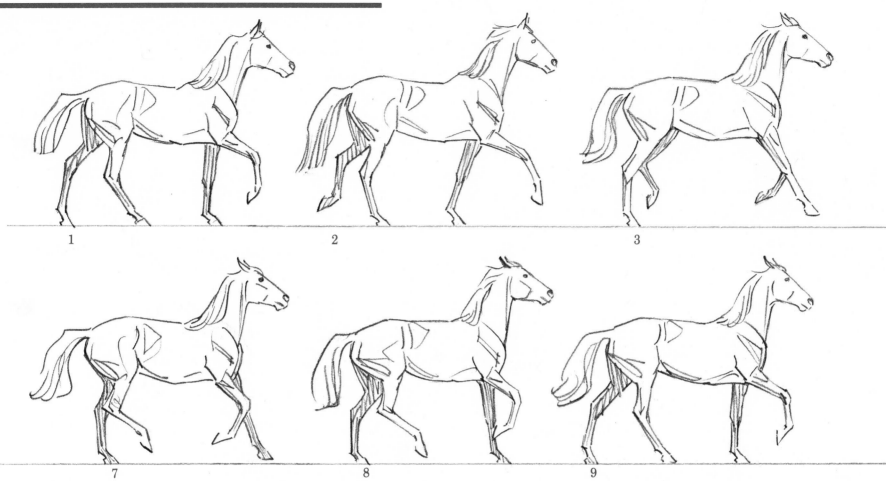

Like the pace, the amble (also called the slowgait or stepping pace) is a lateral-action gait, with both legs on the same side moving forward and backward together. This gait is also known as the singlefoot because it is a four-beat gait in which each foot strikes the ground separately in a smooth action with much elevation though no period of suspension, unlike the two-beat pace. A speeded-up version of the amble is called the rack; the amble and the rack form two of the five show gaits performed by five-gaited saddle horses.

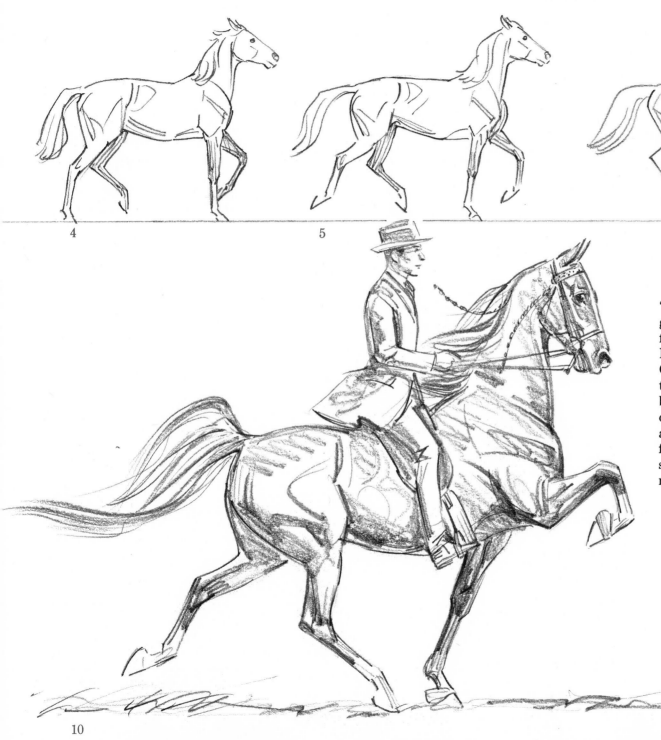

4

5

6

"Rack on!" This is the command given by the judge in the five-gaited saddle horse class. Fig. 10 is a drawing of Winged Commander, one of the greats of the American Saddle Horse breed. When this stallion racked on, he was high-spirited, fiery, and fiercely animated. Notice the free-flowing lines, which give a sense of excitement and movement to the drawing.

10

The sequence below follows a horse over an obstacle from the
point of takeoff (fig. 1) to the landing (fig. 12). Notice that a
good jumper will lower his head slightly as he leaves the
ground. He will fold his forelegs as he crests the jump and then
start opening them as he prepares to land. The hind legs will

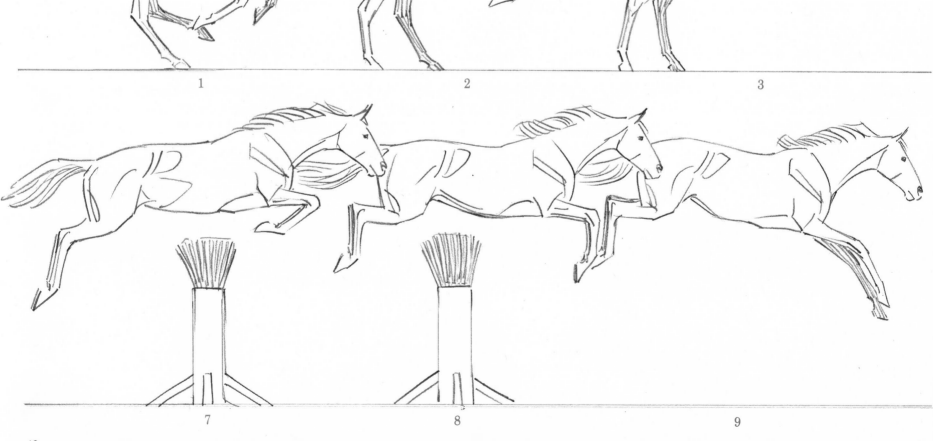

1

2

3

7

8

9

fold in order to clear the jump and remain folded, for when the horse lands they must be ready to come in under him to maintain balance. Notice that one foreleg touches the ground a fraction before the other, which enables the horse to move on freely at the canter after the jump.

4

5

6

10

11

12

When a horse lands after jumping over a fence, the strain on the forelegs is considerable. In this sequence notice what happens to the angle of the pastern on impact.

Jumping uphill

Jumping downhill

When you study a still picture of a horse in action, try to visualize the motion that preceded that action and the motion that will follow. At all times be aware of the overlapping forms (see colored lines), which help give the drawing dimension.

In the horse jumping toward you, the hind legs have left the ground and the knees are coming up to clear the rails.

Note that in the horse jumping away from you the hind legs have not yet left the ground. At this point his knees are just beginning to rise. Compare this with the drawing at the left, which captures the motion a split second later.

In most falls the front end of the horse hits the ground first. Here is a steeplechaser going down after a fence. In this case the momentum of his fall turns him over completely. He twists slightly as he begins to go over and turns his muzzle to avoid slamming it into the ground.

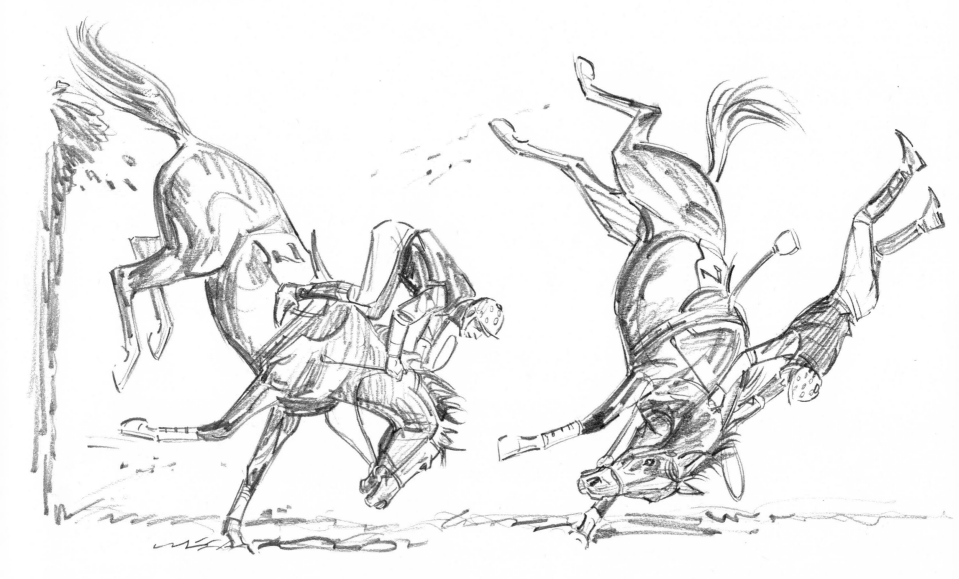

Creating a sequence of this kind is a great exercise in logic. If I begin with a particular action drawing (fig. 1), the following action drawings must follow a logical pattern. What happens to the rider must be just as logical.

Horses fall down in different ways—some falls are funny, some not so funny. On the racetrack or steeplechase course, the falls are fast because of the momentum of the racing horses, and the riders are usually thrown clear.

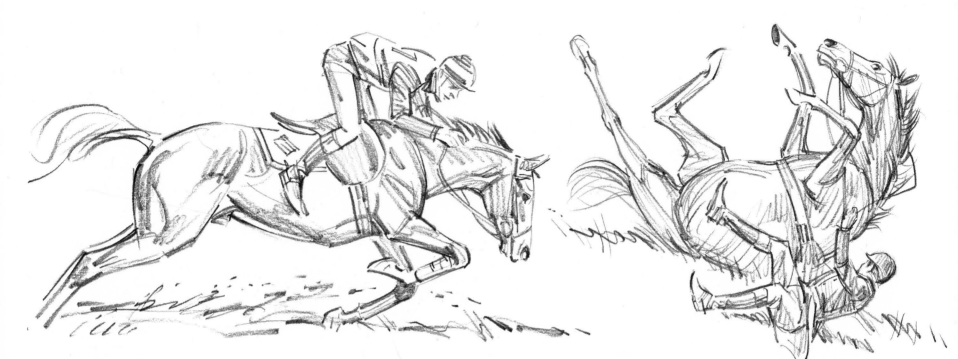

In the hunting field or show ring, however, the falls are much slower and sometimes a rider can get tangled up in the mess.

When drawing this kind of action, always make full use of whipping manes and tails and flying bits of equipment and turf to give your drawing more drama.

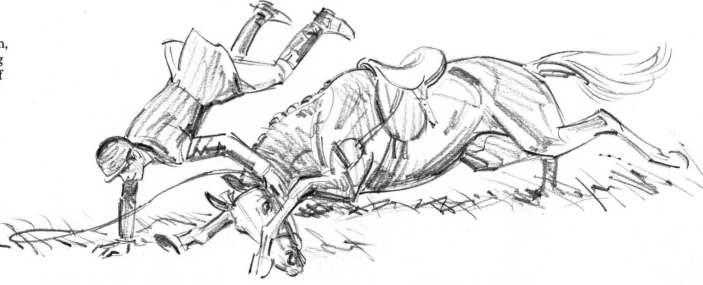

A buck begins basically like a jump except that the horse will drop his head lower as he takes off (fig. 1). In this sequence the bucking horse is turned slightly away from you at the start, but in midair (fig. 4) he twists and lands coming toward you. Notice that as he hits the ground he begins turning again, ready to lift off in another direction. Also note how he kicks out behind as he lands.

1

2

3

In drawing rodeo action, use quick, sharp lines to duplicate the violent motion of the horses. There is little shading. The solidity of the horses is attained by overlapping forms that fit into each other.

A horse may buck out of good spirits or to throw his rider. The rodeo bucker is a professional, for this is the way he earns his living, and good buckers can be as valuable to rodeo producers as first-rate jumpers are to horse-show people. A good rodeo bucker will twist and turn in midair, spinning like a top, sometimes coming to earth facing the direction he has just come from.

4 5 6

This rider is parting company with his mount, and the action of the bucking horse determines which direction the man's fall will take. The horse has bucked to the right and then changed course in midair, twisting off to the left and leaving his rider to make his own way to the ground.

Have you noticed that professional bucking horses are unshod and that their feet are rough-looking?

Bucking out of good spirits.

The only time I do not appreciate a rearing horse is when I'm on his back. Aside from that, the rearing horse can be a majestic sight.

Feel the excitement and put it into your drawing. Vary the thickness of your lines to make the picture more interesting to look at, and don't be afraid to flip that mane and tail around.

Note that the knees of a rearing horse are usually bent.

A horse that shies or spooks usually turns his head toward whatever has startled him, even as he moves away from it. Don't forget to adjust the eyes and mouth to give the horse an appropriate expression.

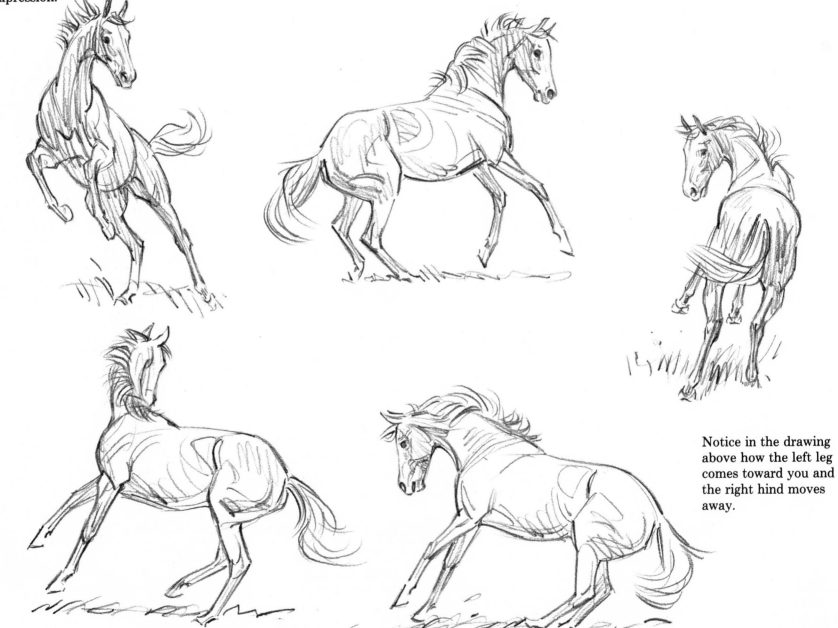

Notice in the drawing above how the left leg comes toward you and the right hind moves away.

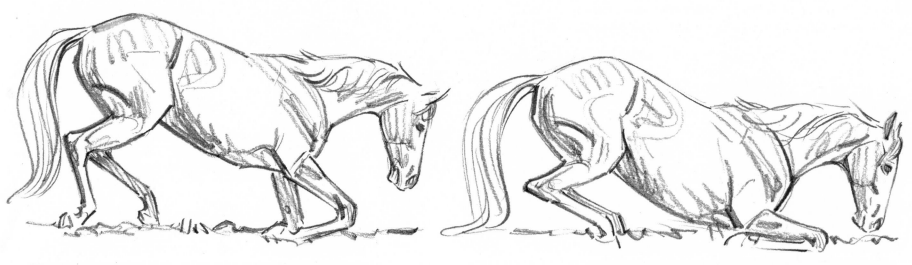

1 First the horse will pick a spot, paw the ground, and start dropping his front end.

2 The hindquarters follow with a thump.

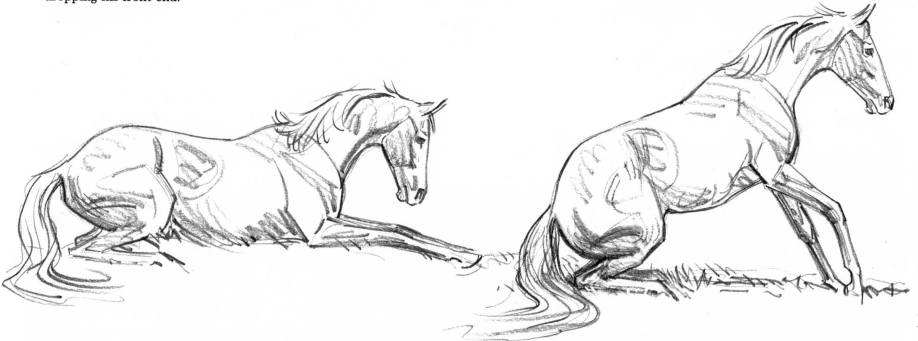

5 The horse will stay down for a moment stretched out like a dog.

6 Then, with a grunt, the front end comes up.

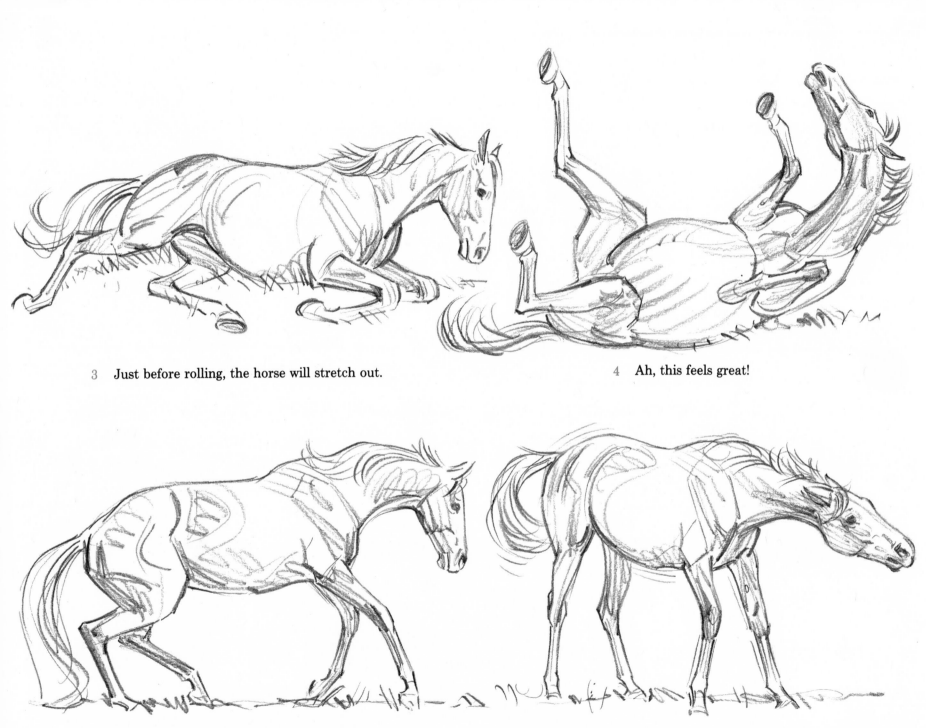

3 Just before rolling, the horse will stretch out.

4 Ah, this feels great!

7 A big heave and he's on his feet.

8 A quick shake to get rid of the dust. That was wonderful!

Notice that one front leg of the adult horse is usually thrust back slightly to help him get his muzzle to the grass.

In profile, the top line of the horse makes a lovely rhythmic curve from head to tail. Make the most of this elegant line in your drawing.

Foals are too long-legged and too short-necked to get their muzzles down to the grass, but as you can see they manage anyway.

The horse seen from all angles in motion—and at rest.

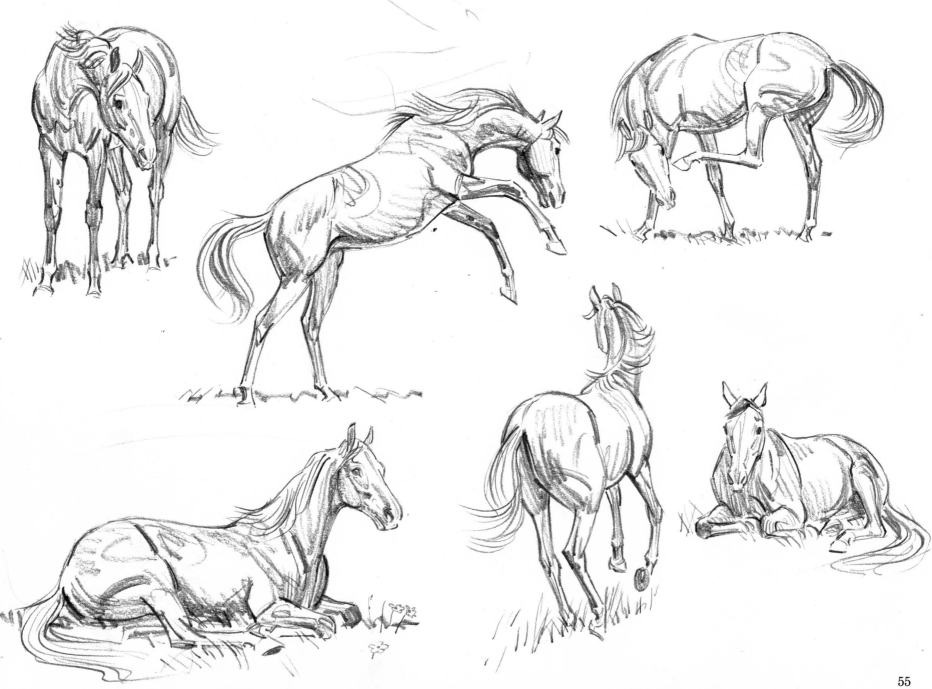

In this section we will look at the different types of horses. First we will check out the perfect horse, since you must be able to recognize ideal conformation in order to identify what is individual about the particular horse you want to draw. We will look at conformation faults, observe a horse from youth to old age, and examine some of the different breeds of horses and ponies and what they are used for.

CONFORMATION

1

A conformation portrait of a horse shows his particular structure, the way he is put together. In such portraits the horse is always depicted in a side view, which shows most accurately the length and relative proportions of neck, shoulder, top line, and hindquarters. The forelegs should be slightly separated in order to show the construction of each leg and foot. ("Daylight to the knees" is a rule of thumb among horsemen.)

The artist doing a conformation portrait must understand what he or she is looking at. It is important to know what good conformation is in order to illustrate any deviation.

How well do you observe? This horse is the same height and length as the one in fig. 1, but he is not as well made nor as well balanced. Let's look at his bad points:

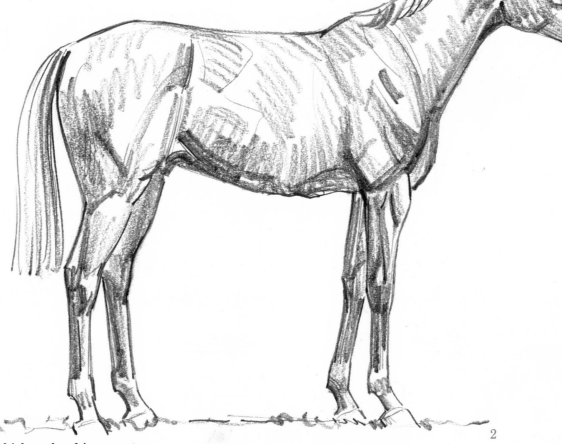

2

The cannon bones are too long, which makes him appear leggy and out of proportion.

The angle of the hind leg is too straight.

His shoulder is also too straight—it should slope at a 45-degree angle from withers to shoulder—and the high point of the croup is set too far back, which gives the horse the appearance of having an overlong back.

The neck is short in relation to the overall length.

Although this horse will probably be able to move normally at all gaits, he may not be as comfortable to ride and may not be strong enough or well balanced enough to perform special tasks, such as jumping or racing, which require athletic ability and endurance.

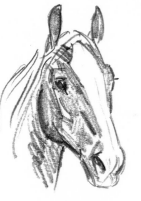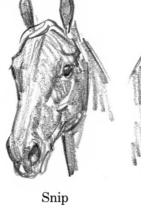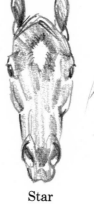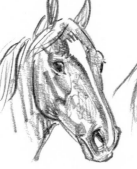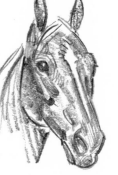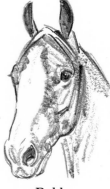

Blaze	Snip	Stripe	Star	Star, stripe, and snip	Star and stripe	Bald

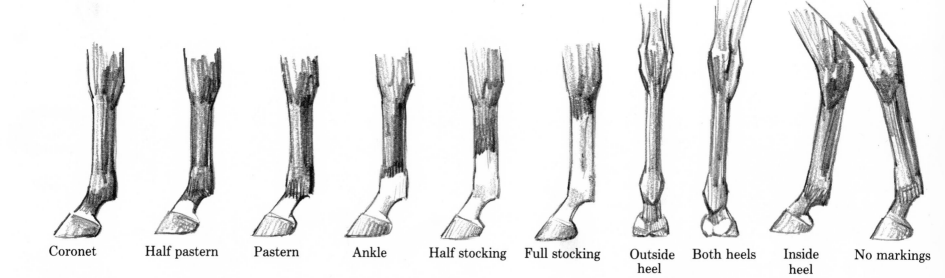

Coronet	Half pastern	Pastern	Ankle	Half stocking	Full stocking	Outside heel	Both heels	Inside heel	No markings

Even in black-and-white drawings you can suggest different colors and markings.

Typical horse colors are black, brown, chestnut (golden yellow to reddish brown with mane and tail of similar shade), bay (reddish brown to dark mahogany, always with black points—mane, tail, and lower legs), and gray. The word roan denotes a coat of solid color with admixtures of white hairs.

Fig. 1 is an Appaloosa. This breed is usually one solid color except for a white blanket with dark spots across the top of the rump.

Fig. 2 is a Paint or Pinto. A horse that is all white with black spots is called a piebald; a skewbald has spots of any color except black.

Fig. 3 is a golden Palomino with flaxen mane and tail.

Fig. 4 is a Buckskin, which has a dull light brown coat with a dark stripe down the back and black points. A dun is similar but has a yellow-gray coat.

The horse in fig. 1 is ewe-necked (the neck seems to bend the wrong way) and his head connects to the neck at the wrong angle. His shoulder is too straight and his back too long. Notice the forelegs; this horse is "over at the knee" (see page 62, fig. 2).

The fig. 2 horse is roach-backed and his "rainy day" rump slopes too steeply.

The horse in fig. 3 is sway-backed or saddle-backed, a condition that often develops with old age.

1

2

3

This is the head of a draft-type horse. Notice the large muzzle and the fullness in the bars of the jaw.

This is the head of a Thoroughbred type. Notice the full cheek and the fine muzzle.

A horse with good rib spring will have this outline when seen from above. This shape allows sufficient room for the lungs, heart, and stomach, and also helps to keep the saddle from slipping back. The colored line indicates poor rib spring.

Fig. 1: Good front end.
Fig. 2: Narrow chest.
Fig. 3: Toes in.
Fig. 4: Toes out.
Fig. 5: Good, square hindquarters.
Fig. 6: Weedy (too narrow).
Fig. 7: Good on top but "cow-hocked" below.

1

2

3

4

5

6

7

61

When you know what a good leg looks like, it is relatively easy to pick out the faulty ones. There are many faults and blemishes, too many to illustrate here, but these are the most common and the most obvious.

1 2 3 4 5

Fig. 1: Good front leg.

Fig. 2: Over at the knee.

Fig. 3: Tied below the knee (the top of the cannon bone is thinner than the bottom).

Fig. 4: Shoe boil at elbow, bowed tendon (the tendon is rounded at the back of the cannon bone); unlike the other faults on this page, these are caused by injury and are not present at birth.

Fig. 5: Weak forearm with long cannon bone; the pastern is too long and slopes at too great an angle.

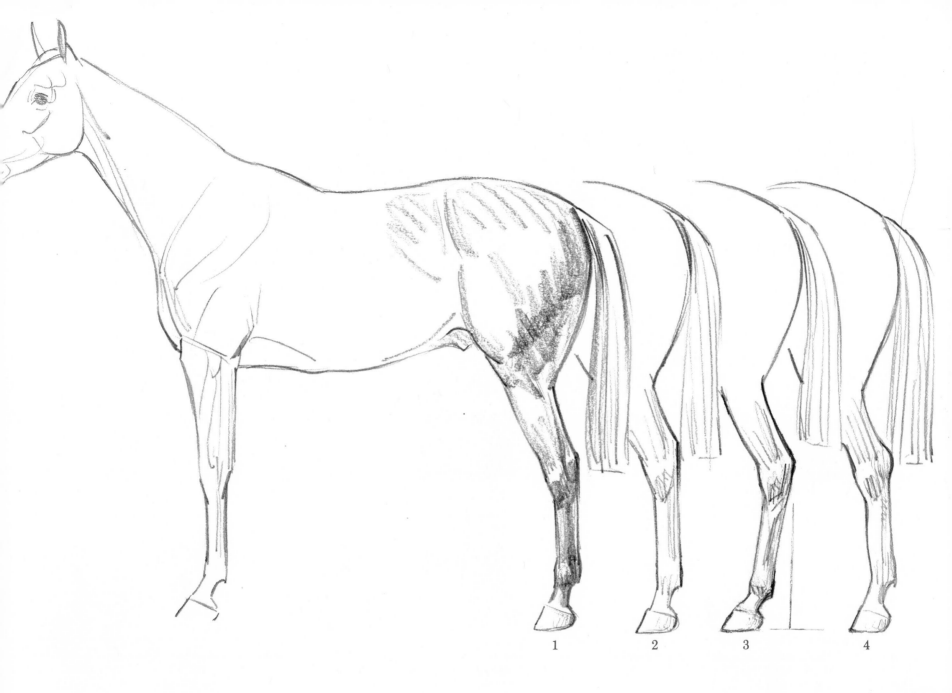

Fig. 1: Good hind leg.
Fig. 2: Cannon bone too long.
Fig. 3: Gaskin is weak and horse is sickle-hocked.
Fig. 4: Capped hock, which shows a "filling," or swollen area, in front of the
 cannon bone; this is caused by injury.

63

At one month he can gallop like an adult horse.

At ten hours of age, this foal seems to be made of angles and sharp bumps. His neck and body are very short and his legs are very long; he is definitely an awkward creature.

In ten days the foal has filled out considerably and the sharp edges have begun to round off.

But he still has to spread his front legs far apart to graze.

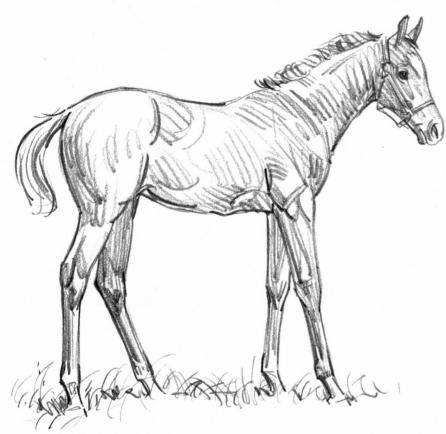

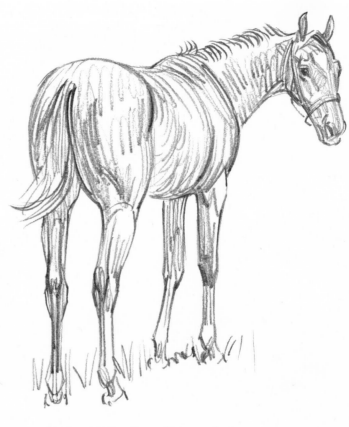

At three months our foal is
beginning to look like a horse.

At six months the colt is ready to
be weaned from his mother. He is
still very much of an adolescent but
he is shaping up rapidly into adult
proportions and size.

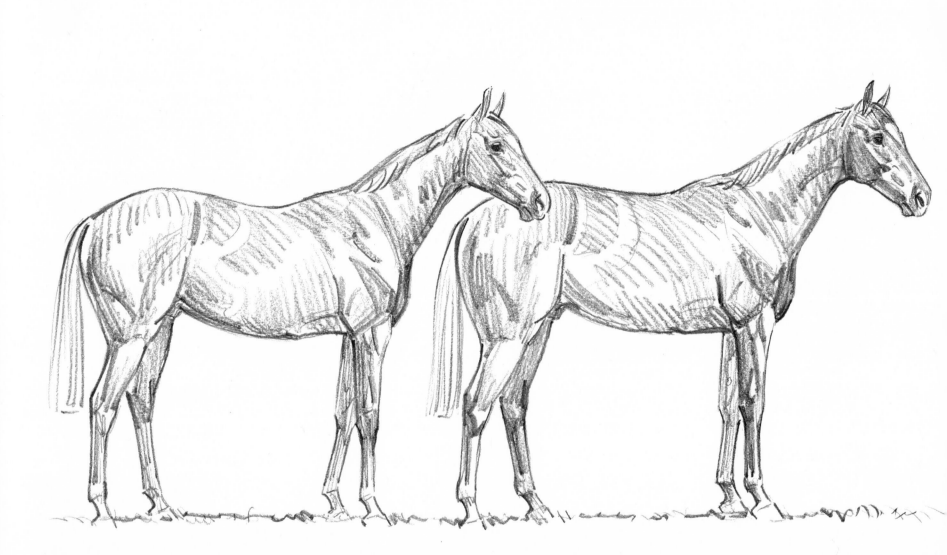

As a yearling (one-year-old), he is still a baby, although he looks much like a grown horse. He is a bit high behind and he generally lacks depth throughout the body. There is also a slight awkwardness in his stance.

When he is mature, in four or five years, this Thoroughbred has reached his maximum height and has filled out all the way around. Notice the feeling of strength throughout the body, which the yearling lacks. In a drawing I emphasize this by defining the withers clearly and straightening the line from the wither to the croup, so there is no sag.

There are several things to remember when drawing an old horse. I have known some horses who remained fat and sassy until the day they died, but generally an old horse loses weight and muscle tone. This is partially because his teeth lengthen as he ages, and the angle at which the upper and lower teeth meet becomes oblique, making it difficult for him to chew the food he needs to keep up his weight and strength. The back sags and the legs are not as strong and straight as they once were. The lower lip droops, the hollows above the eyes deepen, and the skin loses a certain amount of elasticity. Study my drawings and note all the devices I have used to make this horse look old.

Teeth of a
six-year-old horse

Teeth of a
twenty-year-old horse

The Thoroughbred

This breed possesses a high degree of endurance, energy, gameness, quality, and refinement. A Thoroughbred horse generally has a long, muscular frame; a deep, strong chest; prominent withers; long forearms; and short cannon bones.

At right is a conformation portrait of Secretariat, the super racehorse of the century. Every part of him spells strength, even at a standstill. As is depicted below, he ran with great thrust from behind and tremendous reach in front, giving him an exceptionally long stride. It will be a long time before we see another horse like him.

The Quarter Horse

This breed is named for its great speed over short distances, generally a quarter of a mile, and many Quarter Horses are bred today as racehorses. Traditionally, however, the breed has been used to handle livestock and to perform in rodeos, and for this reason is usually pictured in Western tack.

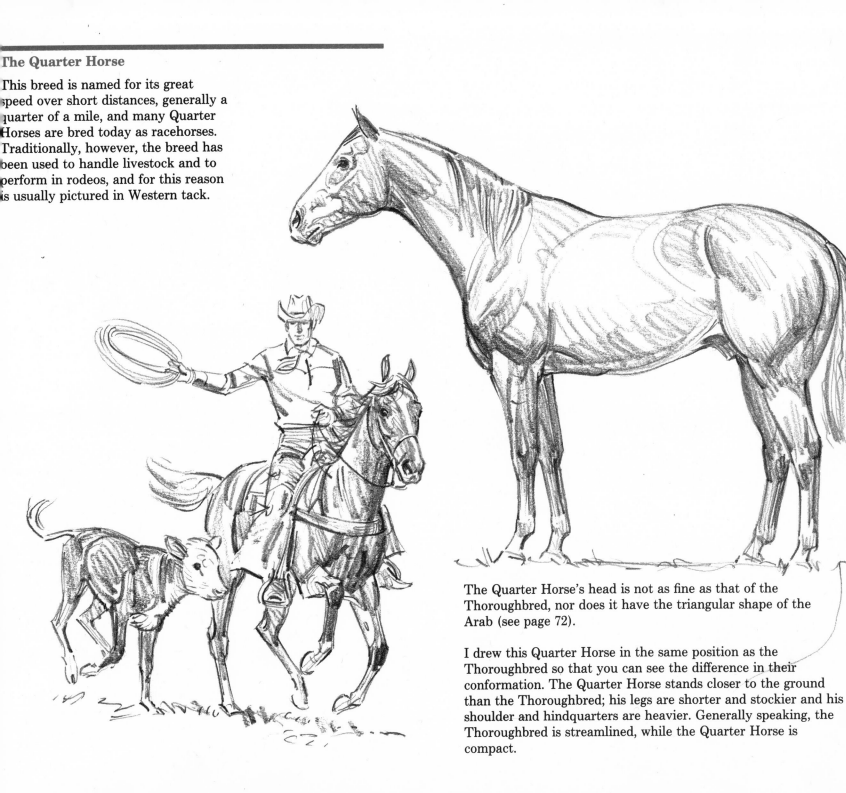

The Quarter Horse's head is not as fine as that of the Thoroughbred, nor does it have the triangular shape of the Arab (see page 72).

I drew this Quarter Horse in the same position as the Thoroughbred so that you can see the difference in their conformation. The Quarter Horse stands closer to the ground than the Thoroughbred; his legs are shorter and stockier and his shoulder and hindquarters are heavier. Generally speaking, the Thoroughbred is streamlined, while the Quarter Horse is compact.

The Morgan

This American breed is known for its good disposition and great strength and versatility. Not all Morgans resemble their common ancestor, Justin Morgan, in conformation, but the Morgan head and neck and general compactness are unmistakable.

The Morgan's speed and stamina have made him valuable as a Western reining and cutting horse.

I like to depict a perky little Morgan pulling a sleigh along a snow-covered road in Vermont, where they have been bred for generations. All is still except for the sleigh bells which jingle merrily to the rhythm of the horse's gait.

Draft Horses

The draft breeds are the powerhouses of the horse world. Shown here are two Percherons, but there are four other important breeds—Clydesdale, Belgian, Shire, and Suffolk. They all have enormous weight and strength, and any drawing of a draft horse must depict these qualities. Your lines should be strong and positive to accomplish this. When viewing a draft horse from the front, notice especially his massive chest and the structure of his forelegs. Compare them to other types of horses.

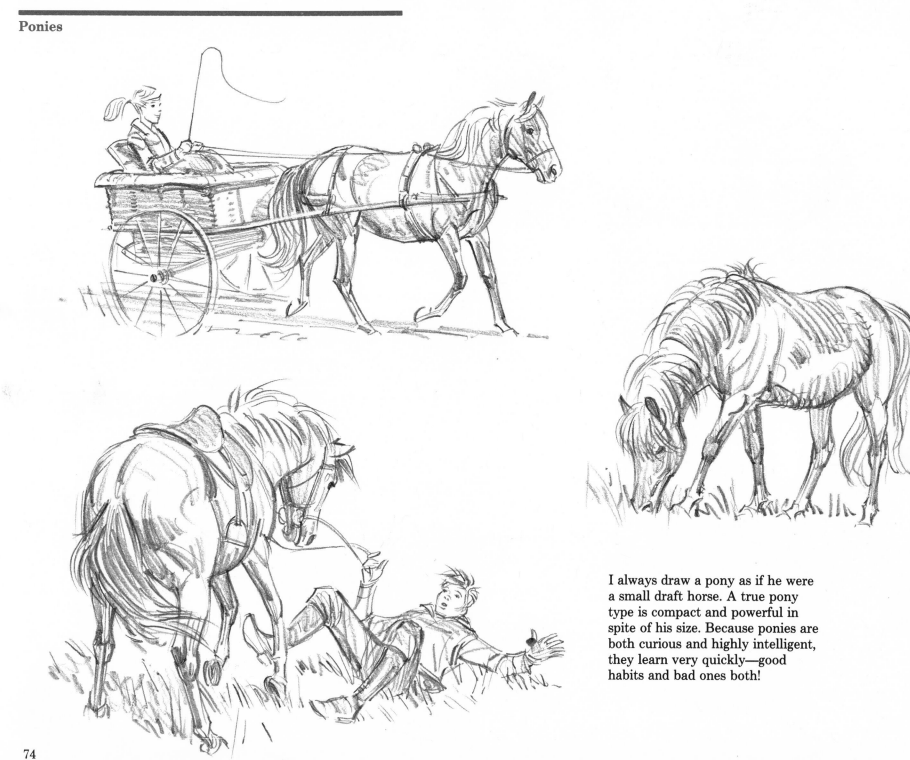

I always draw a pony as if he were a small draft horse. A true pony type is compact and powerful in spite of his size. Because ponies are both curious and highly intelligent, they learn very quickly—good habits and bad ones both!

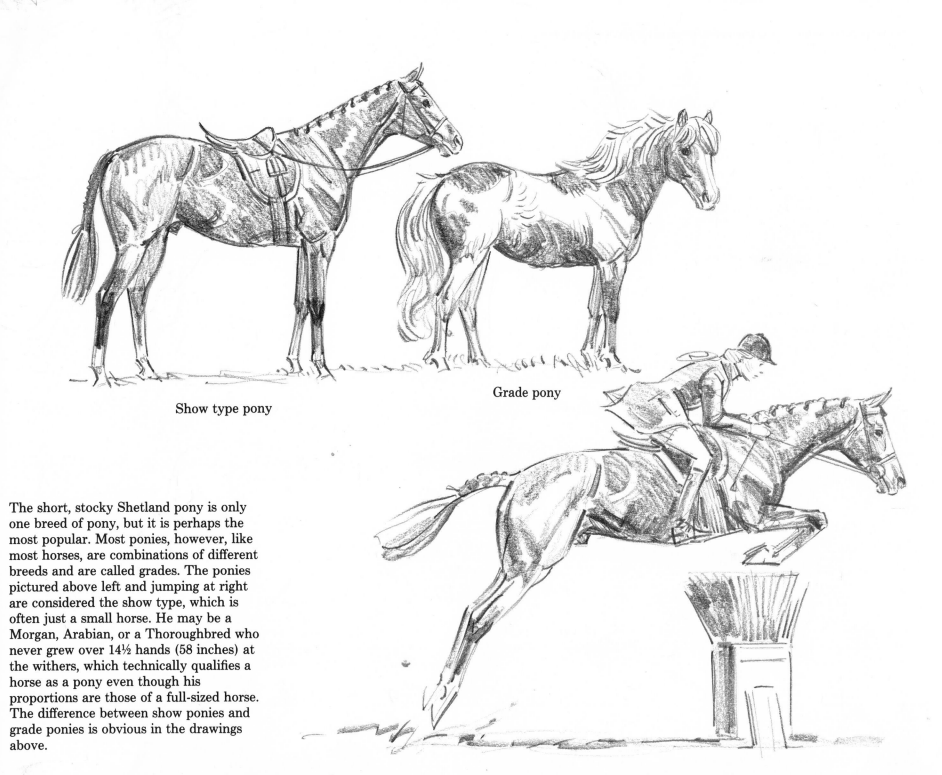

Show type pony

Grade pony

The short, stocky Shetland pony is only one breed of pony, but it is perhaps the most popular. Most ponies, however, like most horses, are combinations of different breeds and are called grades. The ponies pictured above left and jumping at right are considered the show type, which is often just a small horse. He may be a Morgan, Arabian, or a Thoroughbred who never grew over 14½ hands (58 inches) at the withers, which technically qualifies a horse as a pony even though his proportions are those of a full-sized horse. The difference between show ponies and grade ponies is obvious in the drawings above.

Relative Heights

The height of a horse is measured in hands from the ground to the top of the withers; one hand equals four inches. Therefore, a twelve-hand pony is 48 inches in height. For drawing purposes it is necessary to have a fair idea about the relative sizes of horses, especially if you intend to compose a group picture.

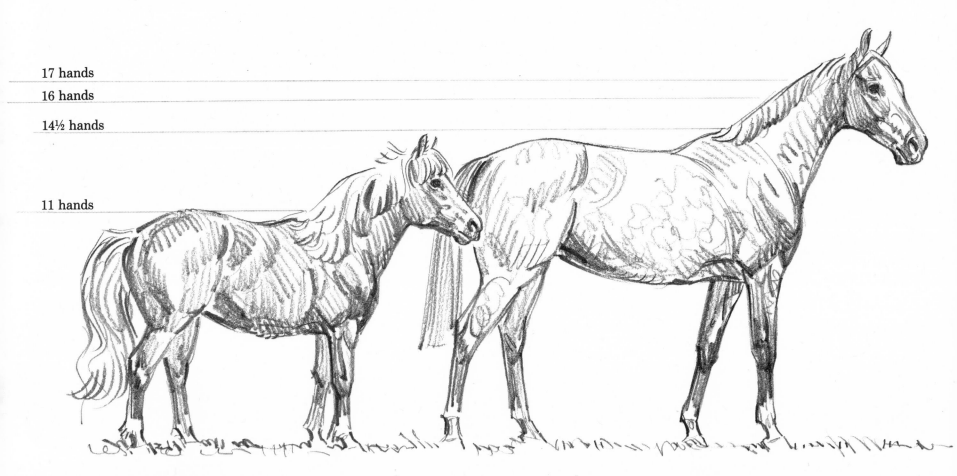

17 hands

16 hands

14½ hands

11 hands

The Shetland is the smallest of the pony breeds. His height ranges between ten and eleven hands.

The Connemara pony averages about 14½ hands, the limit for pony height.

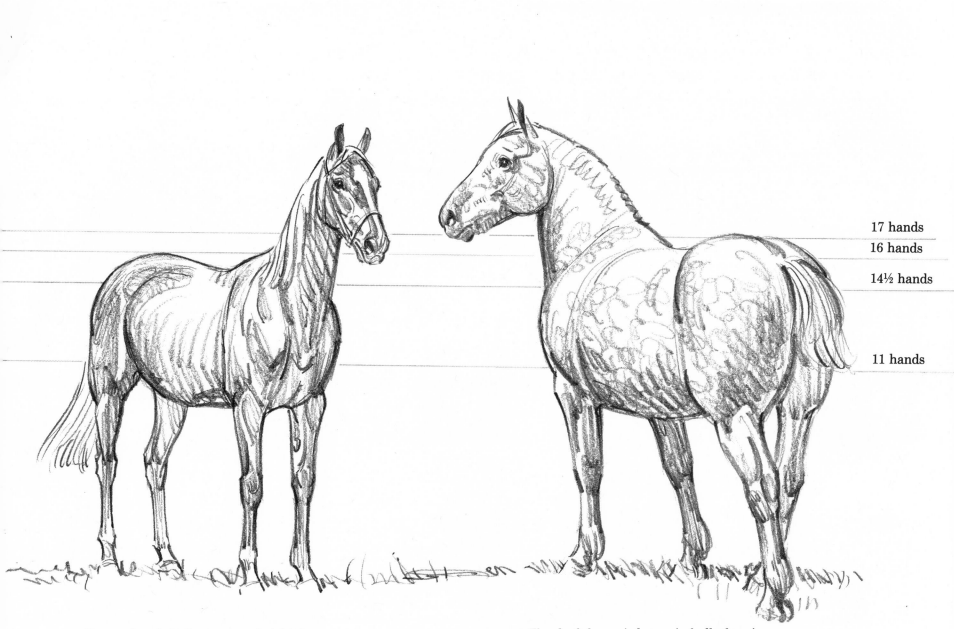

17 hands

16 hands

14½ hands

11 hands

Sixteen hands is the average height for a
Thoroughbred horse.

The draft horse is larger in bulk than in
height. This one is about seventeen
hands, but many are under that height.

Hunt-seat (or Forward-seat) Equitation

This style lends itself mostly to cross-country riding and jumping. It is an easy, supple position, and the horse and rider should be pictured alert but relaxed. The rider's forearms and hands follow the line of the reins, which are held in both hands. The calf of the leg is slightly behind the girth of the saddle; I always draw an imaginary straight line from the base of the rider's throat to the heel.

The saddle above is an all-purpose type, suitable for hacking cross-country or jumping over fences. Note that the bit is a snaffle with a single rein.

Stock-seat Equitation

The rider's leg is held straighter in Western-type riding than in the hunt seat, and the rider carries the reins in one hand. The curb bit has a long shank to which a single rein is attached.

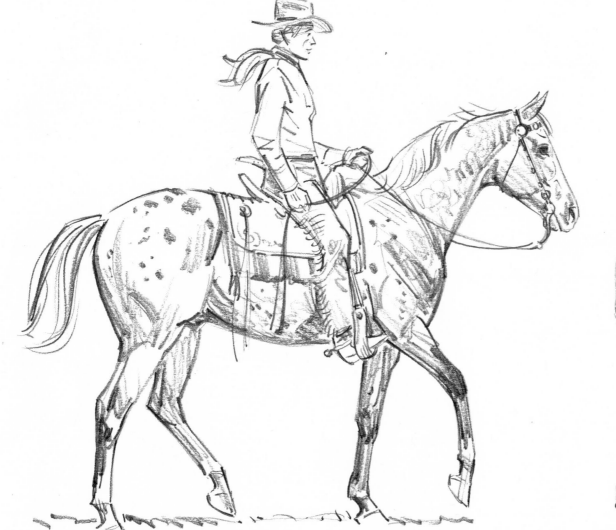

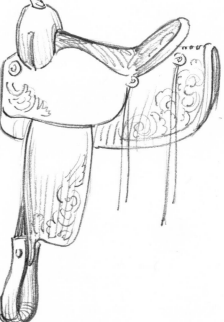

This is a typical Western or stock saddle. There are as many varieties and designs of this type as there are in English saddles.

Saddle-seat Equitation

The horses below are three-gaited American Saddle Horses, which perform in the show ring at the walk, trot, and canter. The rider sits far back on the horse in order to accentuate the horse's front action, which is high-stepping and animated. The appearance of the Saddle Horse should be one of great elegance, and the artist must always bear this in mind. Notice how the horse's shoulders move with the action of the legs; also note that the horse's hooves are longer than normal, which helps to create the high action. The saddle is much flatter than the type used in hunt-seat equitation.

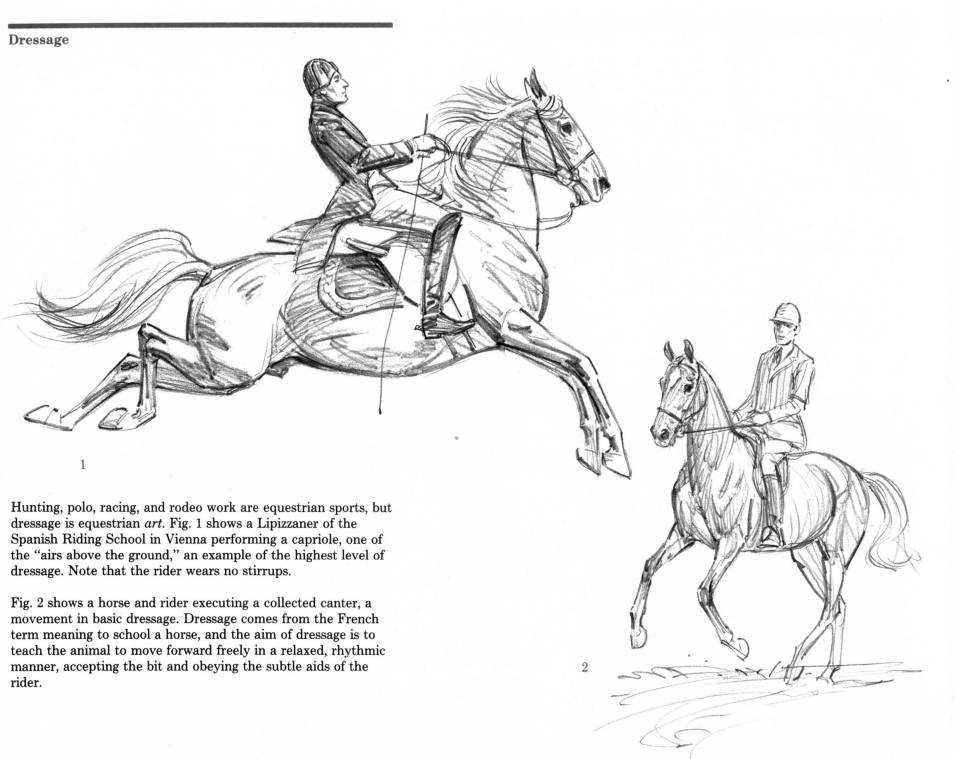

1

Hunting, polo, racing, and rodeo work are equestrian sports, but dressage is equestrian *art.* Fig. 1 shows a Lipizzaner of the Spanish Riding School in Vienna performing a capriole, one of the "airs above the ground," an example of the highest level of dressage. Note that the rider wears no stirrups.

Fig. 2 shows a horse and rider executing a collected canter, a movement in basic dressage. Dressage comes from the French term meaning to school a horse, and the aim of dressage is to teach the animal to move forward freely in a relaxed, rhythmic manner, accepting the bit and obeying the subtle aids of the rider.

2

The game of polo has more violent action than any other equestrian sport. Here the artist can test his ability for drawing action and also display his knowledge of the game. When I do complicated action drawings like this, I first do a rough sketch and then I redraw each horse and rider separately. When I put it all together I am always careful how I overlap the elements of my picture. The drawing must re-create the confusion of the skirmish but at the same time be as clear as possible so that the viewer can follow the action.

Fox Hunting

When I picture a fox-hunting scene, I find myself drawing more than just horses, for riders and hounds and many other things are involved in this traditional sport. With fox-hunting subjects, you must pay strict attention to detail just as the participants do—the shape of the whip, the clothing, and the horse's tack and braids.

Wild Horses

An old mustanger once told me that mustangs were a motley bunch but that every once in a while you come across one of special quality and courage. This horse is one of those. Pursuit and escape are my themes here. To execute this kind of picture you should try to *become* that mustang in order to understand the terror he feels. You must claw your way up that crumbling bank to freedom and know what a horse is capable of doing in desperate circumstances.

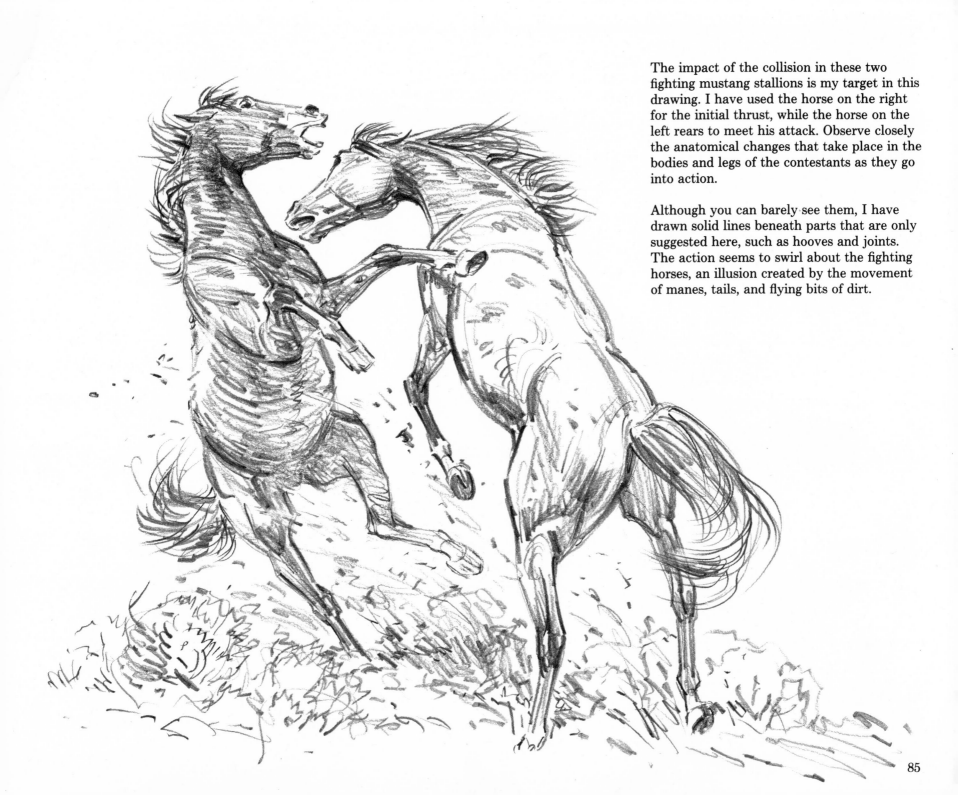

The impact of the collision in these two fighting mustang stallions is my target in this drawing. I have used the horse on the right for the initial thrust, while the horse on the left rears to meet his attack. Observe closely the anatomical changes that take place in the bodies and legs of the contestants as they go into action.

Although you can barely see them, I have drawn solid lines beneath parts that are only suggested here, such as hooves and joints. The action seems to swirl about the fighting horses, an illusion created by the movement of manes, tails, and flying bits of dirt.

This final section is devoted to the various methods of drawing that I have used over the years. The noted equestrian artist Paul Brown introduced me to the overlay method, which I in turn pass along to you along with other techniques that I have developed to cope with the many problems involved in drawing horses. It is important to remember, however, that there are no set rules. As you progress you will combine the techniques you were taught with your own discoveries. This process of learning and developing will take time, but eventually you will approach drawing in a way that will suit your own particular temperament. From that point on, your techniques will be your very own.

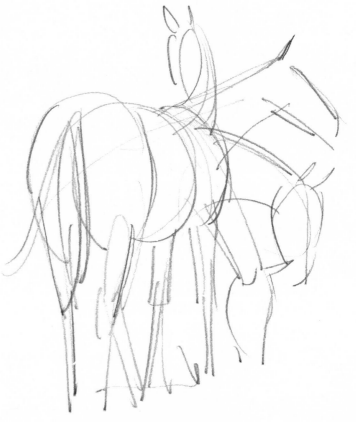

Or he could be moving away.

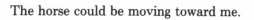

The horse could be moving toward me.

OVERLAY METHOD

The basic theory behind this method is to save what is good and to redraw only that which is not. This technique enables you to get where you are going much faster and more accurately than if you had to start over from the beginning every time you made a mistake.

All you need is a pad of tracing paper and a soft pencil. Draw boldly. If a head or a leg looks wrong, sketch in another right on top of it. Keep drawing until you see what you are looking for. For this demonstration, I plan to draw a horse in a pasture.

I decide to draw a profile of a grazing horse instead.

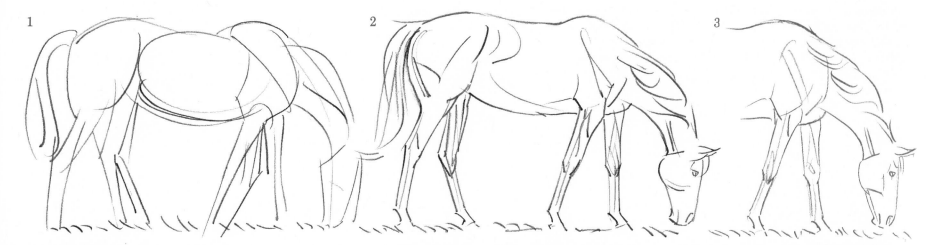

1

I like to sketch freely on the tracing paper when I begin. My lines go down every which way as I feel out the form. In fig. 1 I am starting to see the horse.

2

To get fig. 2, I place tracing paper over fig. 1 and trace only the lines that will depict the grazing horse. But now he seems too long.

3

To correct this, I place tracing paper over fig. 2 and redraw only the front end.

4

I keep fig. 2 under the tracing paper on which I sketched the front end (fig. 3), but I move fig. 2 forward until the distance between the front end and the back seems right. Then I trace the hindquarters and join them to the front end.

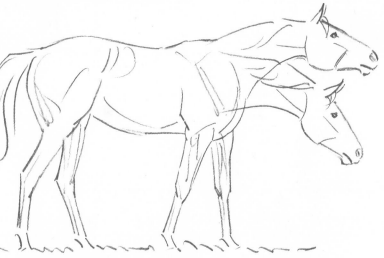

5

If you want to draw the same horse with his head raised, trace the body in fig. 4 onto a fresh sheet of tracing paper. Move the drawing underneath around until the angle of the neck seems right, then trace it and join it to the body.

I begin my drawing with a single line—one that will best summarize the action I want to draw, in this case a bucking horse. When a horse bucks, he literally seems to break in two. He will thrust his body upward and then drop his head between his forelegs as he ascends. Therefore I will begin to draw this action with a line that shoots upward and then breaks downward.

Next, I roughly sketch in the general shapes of the shoulder area, the middle, and the hindquarters, eventually adding the neck, head, and legs with freely drawn lines.

1

2

By fig. 3 the horse has acquired a mane, tail, eye, and nostril. Notice how the addition of these details starts to bring my horse to life.

If I should decide to alter the action of the legs or raise the head somewhat—or to lengthen or shorten the body—I can resort to the overlay method, saving what I want and eliminating the things I do not.

3

MAKING CORRECTIONS

Sometimes looking at your drawing in a mirror will show up mistakes, but I find that it is difficult to make corrections using a mirror. Here is the correction method that suits me best. I will make a drawing on a sheet of tracing paper and then turn the paper over to look at my drawing in reverse. This gives me a fresh look at the horse, and I can often see mistakes this way. I will correct my mistakes on the wrong side and then flop the paper back to its original side, erasing the areas that were wrong. (I use a kneaded rubber eraser because it will not tear the paper.) My corrections will show through the paper, and I can sketch in fresh lines over it. I continue to flop the paper back and forth, correcting as I go until my drawing looks correct from both sides.

If my tracing paper should start coming apart under this abuse, I slip it under a fresh sheet, trace everything down, and keep on going.

This little discovery of mine will give you a sense of the general relationship of forms. In a three-quarter view, the distance from head to withers to rump and the distance between the front and rear legs are the same whether the horse is facing toward you or away. But when the horse is seen in a three-quarter back view, you must enlarge the hindquarters and the hind legs as indicated by the colored line in fig. 3, because they are now closer to you than they were in fig. 1. Otherwise the silhouette will remain the same.

1 Three-quarter front view 2 Remove all inside lines 3 Put in new lines to make a three-quarter back view

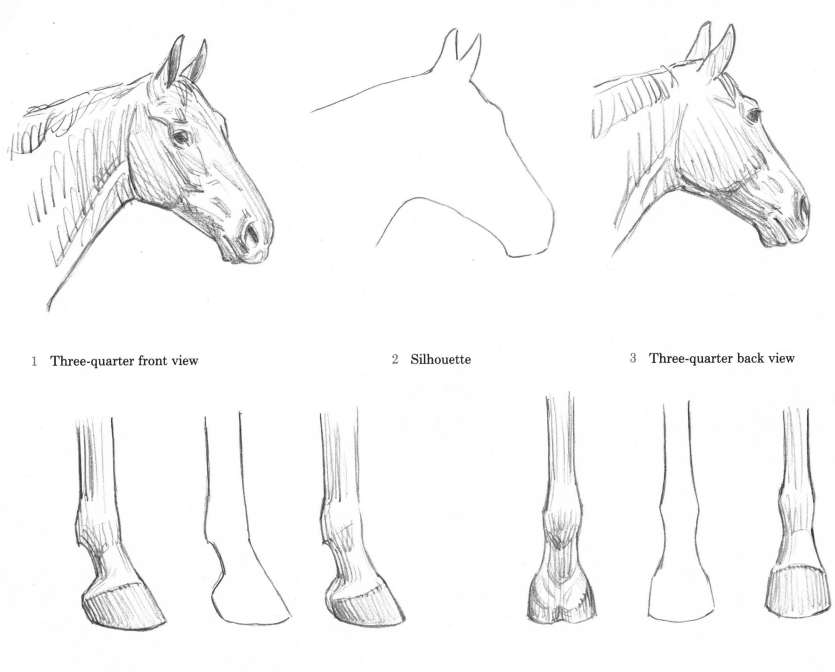

1 Three-quarter front view 2 Silhouette 3 Three-quarter back view

1 Three-quarter front view 2 Silhouette 3 Three-quarter back view 1 Direct back view 2 Silhouette 3 Direct front view

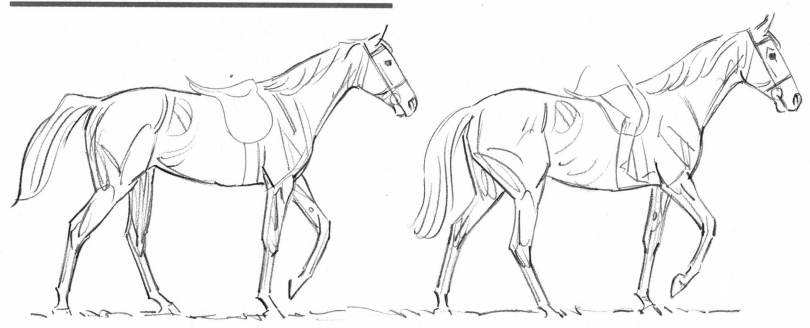

1. Start with the saddle, which goes on just behind the withers.

2. Next I draw in the lower half of the rider, working downward from the saddle. The English rider's foot should be just about even with the bottom line of the horse's belly, or slightly above.

I follow the same procedure with a three-quarter front view.

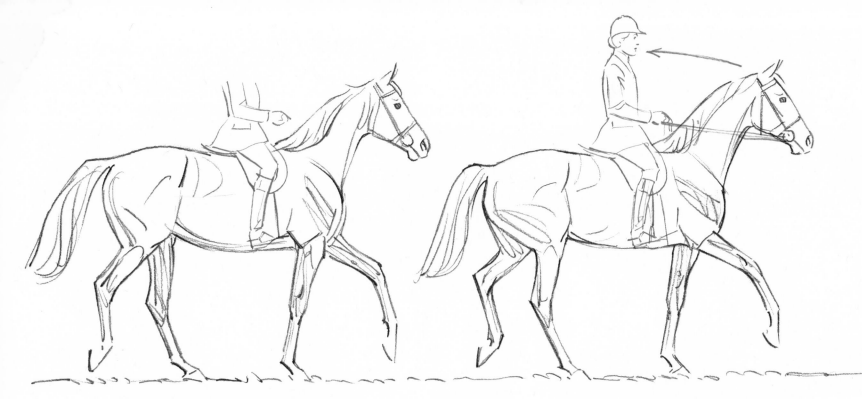

3. If I begin with the rider's seat in the saddle, he'll still be there when I finish, not below or above it.

4. Then I work upward from the saddle. I use the top of the horse's head as a guide, knowing that if the head should swing back, it would be even with the rider's chin.

Three-quarter back view

The cowboy's foot will often hang below the horse's belly because he rides with a longer stirrup than the hunt-seat rider above.

A good photograph can be very helpful to the artist as a reference for certain details, especially in making portraits of horses with special characteristics. But photographs may distort form, even though they look all right at first glance. Remember that the horse is a long animal. If the photographer focuses too close to the head, the horse in the photograph will have a head that is too large and a body that is too small, especially in the hindquarters. If the photographer focuses too close to the rear end, the reverse will happen. The experience of looking at many horses will help you detect the distortion and correct it in your drawing.

One way to check for distortion is to place a sheet of tracing paper over the photograph and trace the outline of the horse. When you remove the photograph, the distortion will pop out, for your eyes will not be influenced by the details in the photograph.

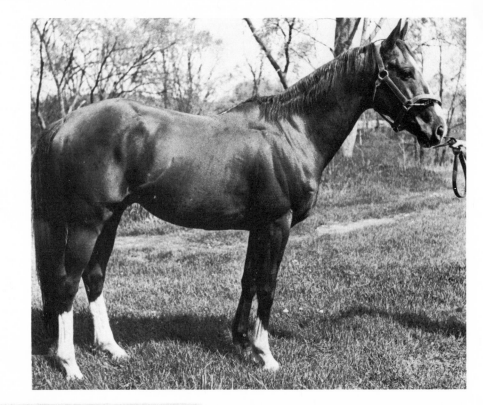

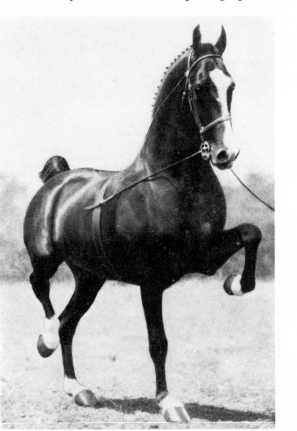

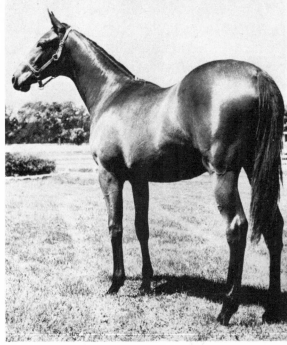

The photographs of horses on this page are obviously distorted. Because they are photographs, we have a tendency to believe that they must be correct, but nothing could be further from the truth. To get a good photograph of a horse in profile, focus your camera a bit forward of the horse's hip. Using a telephoto lens and shooting from a distance will enable you to get a true picture of a horse in any position.